CHARLESTON MYSTERIES

Ghostly Haunts in the Holy City

Cathy Pickens

Haunted America

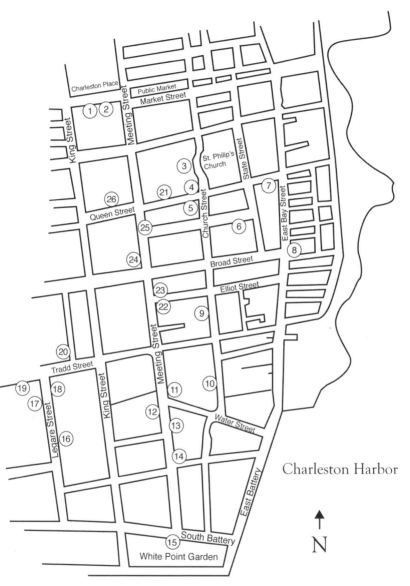

Charleston, South Carolina

Published by Haunted America
A Division of The History Press
Charleston, SC 29403
www.historypress.net

Cover design by Marshall Hudson.

First published 2007
Second printing 2008
Third printing 2009
Fourth printing 2010
Fifth printing 2012

Manufactured in the United States

ISBN 978.1.59629.312.0

Library of Congress Cataloging-in-Publication Data
Pickens, Cathy.
Charleston mysteries : ghostly haunts in the holy city / Cathy Pickens.
 p. cm.
ISBN-13: 978-1-59629-312-0 (alk. paper)
1. Ghosts--South Carolina--Charleston. 2. Haunted places--South
Carolina--Charleston. I. Title.
BF1472.U6P53 2007
917.57'9150444--dc22
2007026746

Contents

Part I: The Walking Tour
Introduction to the Tour 9
Tour Outline 11
The Tour 17

Part II: Charleston's Past: The Intriguing Bits
"The Stormy Petrel": Author's Note 87
The King's Favor 89
Threats on All Sides 94
Nature's Wrath: Storms Past and Present 98
The Cruel Institution 102
Plat-Eyes and Boo-Hags 106
Crime and Punishment 110
The First Civil War 115
Threats Real and Imagined 125
The Fish Boat 128
The Murderous Military Governor 135
The Groaning Earth 143
Dead and Buried 147
Good Manners 149
Saving the Past 151

Bibliography 155
About the Author 160

PART I

THE WALKING TOUR

Introduction to the Tour

Charleston, one of the oldest and most stately of cities, is also one of the most haunted. Walk any Charleston street and notice the buildings: the cracked façades canted drunkenly with age, the steps worn by innumerable boot treads. Take a deep breath. Even the air—sometimes dull and heavy with summer humidity, other times damp and chilling—smells of age and time. The harbor breeze across the Battery and earthen odors rising from the open windows of a centuries-old home carry whispers of ages and mysteries.

This walking tour will show you Charleston's other world. Amidst quaint, old-world charms and bright gardens hides another Charleston, one of mystery and murder, of ghosts, pirates and underworld hoodlums, a Charleston not many see—or want to see.

The tour takes an easy two hours. You can begin at any point. But a word of warning: unless you are exceptionally stout of heart—or incredibly reckless—don't attempt this tour late in the day. The sun drops quickly on the far

side of the Ashley River and darkness will be upon you suddenly. The charm of Charleston will fade as the old-fashioned street lamps cast more shadows than light, and you will find yourself confused. Was that a footfall on the cobbled street behind you? Or your own breath rattling raggedly in your chest as your pace quickens?

Hardly a street or a building in Charleston is spiritless. Journey wisely. You know the limits of your own imagination. Take what precautions you feel are necessary. Only the bravest—or most foolhardy—will visit Charleston's eerier sites on a gray day with a cold wind off the bay.

Wear comfortable shoes. You never know when you might feel like running a block or two. And remember, leave your garlic bulbs and silver crucifixes at home. Those are for vampires and will do you no good here. Nothing scares a Charleston ghost, except maybe the fear that it will be forgotten.

Have a spookily good visit.

TOUR OUTLINE

1. 139 Market Street (across from Charleston Place)
Scene of the ice pick murder of an ex-policeman during Charleston's underworld years of gambling and "blind tigers" (illegal liquor houses). Notably, the ice pick murder occurred the day after Halloween, the same day as the mysterious shooting of Mrs. Ravenel (#11).

2. Market Street at Charleston Place
Site of 1927 shooting of Rumpty Rattles Hogan, a Charleston gangster.

3. St. Philip's Churchyard, Church Street
(A) Grave marker tells how a murderer was captured with the help of a young boy.
(B) The Gray Man haunts the cemetery, foretelling the deaths of those who see him.

4. Pirate House, 145–147 Church Street
Reputedly a hangout for eighteenth-century Charleston pirates.

5. Dock Street Theater, 135 Church Street
The exterior is painted haint blue, a color used in Charleston to ward off spirits.

6. The Pink House, 17 Chalmers Street
An early eighteenth-century tavern reportedly popular with pirates, including Charleston's female pirates.

7. Wagener Building, 161 East Bay Street
The Wagener Building is revisited by the hanging figure of an unsuccessful cotton planter.

8. Exchange Building and Provost Dungeon, 122 East Bay Street
Site of Revolutionary War prison where the British held Charleston notables, criminals and prostitutes.

9. Cabbage Row, 89–91 Church Street
The real-life scene of the fictional tenement that housed the ill-fated lovers Porgy and Bess.

10. Thomas Rose House, 59 Church Street
The house is haunted by the whistling doctor who died calling for the woman he had loved from afar.

11. Murder of Mrs. John Ravenel, Meeting Street at Water Street

Site of 1933 shooting of Mrs. John Ravenel, a Charleston socialite. The murder has never been solved, although some unusual solutions have been suggested.

12. 37 and 39 Meeting Street

Ghosts live in one house and pirate treasure is buried in the backyard of the other, guarded by the ghost of a pirate left to protect the treasure from thieves.

13. Daniel Huger House, 34 Meeting Street

The house itself has tried to kill—and once succeeded.

14. Perroneau House, Meeting Street at Atlantic Street

The ghost of Colonel Isaac Hayne, a Patriot hanged by the British for treason, returns to this house as he promised Mrs. Perroneau he would.

15. White Point Gardens

Several stories center on White Point Gardens:

(A) Stede Bonnet, Charleston's gentleman pirate.
(B) Theodosia Burr, Aaron Burr's daughter, captured by pirates.
(C) Battery Carriage House Inn's two ghostly guests.
(D) The *News* editor murdered in 1889 by a local doctor.

16. Simmons-Edwards House, 14 Legare Street
This house witnessed a duel fought between the upstairs windows of 14 and 15 Legare, and one of Charleston's most unusual marriages.

17. 31 Legare Street
The Heyward house is where one of Charleston's "most tragic and quietest spooks" sits in the library, slumped at the desk with his head in his hands.

18. The Sword Gates, 32 Legare Street
The site of Madame Talvande's School for Girls, where Madame Talvande still roams the halls, trying to prevent another elopement.

19. Gateposts, 131 Tradd Street
The gateposts mark the site of the home of Mrs. Simmons, where her ghostly carriage can still be heard at night rolling down the alley to the place where her house once stood.

20. John Stewart House, 106 Tradd Street
A carriage has been heard pulling up in front of this house. The carriage may come to claim Francis Marion, who once leapt from a window to escape the British, or it may come for someone else.

21. Walled Gardens

Backyard privy excavations have uncovered evidence of centuries-old murders.

22. St. Michael's Rectory, 76 Meeting Street

A ghostly dragging sound, as though an injured person is being carried up the stairs, has echoed in this house since a duelist shot in the alley behind the house was carried here to die. The house was also the home of Judge Bay, who sentenced Lavinia Fisher, Charleston's most famous female mass murderer, to hang.

23. St. Michael's Churchyard

The site of the wedding of the poisoned bride who, according to some reports, died at the altar and is buried in the churchyard.

24. County Courthouse, Meeting Street at Broad Street

The site of the 1819 trial of Lavinia Fisher, the first woman sentenced to hang in South Carolina and now known as Charleston's most famous mass murderer.

25. The Streetcar Murder, Meeting Street

Streetcar tracks once ran down the center of Charleston streets. A murder for love was committed on one of the streetcars, at the end of the line.

26. Poogan's Porch, 72 Queen Street
A lonely lady invites people in to visit.

(Return to Charleston Place.)

Note: The tour forms a loop and can be started and finished at any point.

THE TOUR

Begin on Market Street across from Charleston Place.

1. 139 MARKET STREET

On November 1, 1933, the day after Halloween, two of Charleston's most celebrated murders occurred at almost the same time and only blocks apart. One involved a sixty-four-year-old Charleston socialite (see tour stop #11); the other was the ice pick murder of an ex-policeman.

The ice pick murder was one of many Charleston crimes to take place on Market Street, an area once known for its liquor and gambling houses and questionable patrons. That November night, former policeman Charles G. Hilton and a man named Earl Riggs got into a fight in a "bootleg establishment" on Market Street. After the fight, Hilton went with some other fellows to the Atlantic Lunch at 139 Market Street (across from what is now Charleston Place). Later, they headed west down Market.

Riggs caught up with them just after they crossed King Street. Riggs grabbed Hilton in what first appeared to Hilton's companions to be a friendly hug. Then he stabbed Hilton in the head with an ice pick. Riggs threw the bloody ice pick in the gutter and fled as Hilton collapsed onto the pavement.

Newspaper accounts speculated that Riggs was angry with police over his February arrest during a police crackdown on "undesirables." The police had been trying to squelch a war between rival slot machine operators.

139 Market Street. Scene of a 1933 "underworld" ice pick murder. *Courtesy of Tyler LaCross.*

2. MARKET STREET AT CHARLESTON PLACE

The ice pick murder wasn't the first—or the last—Market Street murder with gambling and illegal liquor connections. On October 25, 1927, at one o'clock in the morning, Frank J. "Rumpty Rattles" Hogan, age fifty-one, went to the Peking Chop Suey to pick up his eighteen-year-old girlfriend as she got off work. Rumpty was killed by a shotgun blast aimed from a second-story window at 141 Market. His killer—Leon Dunlap, a rival liquor dealer—was arrested on the spot along with Rumpty's son-in-law, Country Boy Riggs.

Rumpty was a middleman in Charleston's thriving underworld. A rugged, well-built man with a fierce temper, he never backed away from a fight. But he was also unexpectedly civic-minded. People with nowhere else to go could always find a place to sleep and soup and bread to eat at Rumpty's house. Rumpty had even been involved in the election campaigns of some Charleston mayors. Businesses like those on Market Street couldn't, after all, survive without the help of friends in high places.

Despite South Carolina's own version of Prohibition, liquor and gambling weren't considered vices in this seaport town, and Market Street kept late hours, its gambling dens and "blind tigers" (illegal saloons) catering to a rough and thirsty crowd. (An estimated

250 blind tigers operated in the city when it had a population of only 60,000 people.) The *News & Courier* said in 1933 that "Market Street, where both killings [the ice pick murder and Rumpty's shooting] took place, for decades has been a center of Charleston's underworld activities, and in recognition of this fact, the police watch on the street is heavier than any other section of the city."

Rumpty's killing might have been forgotten, along with countless others, except that his killers—who had waited for hours in the doorway of 141 Market for Rumpty to arrive—were acquitted. Even though the killers fired their brand-new shotgun from a second-story window and killed Rumpty while he was highlighted by a streetlamp, the jurors felt that the killers had acted in self-defense.

Late in the evening, listen closely for the sounds of clinking glasses and drunken laughter and strains of tinny music. This was, after all, the place that made flappers and the Charleston dance famous. Of course, the gangsters are gone now. But you'll want to watch those darkened doorways and unlighted second-story windows if you decide to visit some of the nightspots after dark.

Continue east on Market; turn right on Church Street.

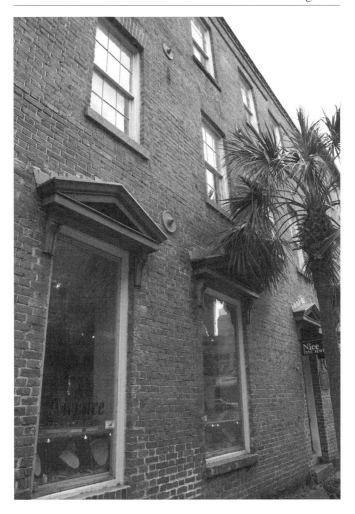

141 Market Street. Gangster "Rumpty Rattles" Hogan was gunned down from this window. *Courtesy of Tyler LaCross.*

The Public Market.*Courtesy of Cathy Pickens*.

3. ST. PHILIP'S CHURCHYARD, CHURCH STREET

No mystery tour of Charleston can leave the graveyards unvisited. Enter the western cemetery, across from St. Philip's front door, and look along the right wall for two flat stones: a triangle and a square. The grave marker of Nicholas John Wightman is the only one in Charleston to detail the occupant's murder and its solution.

On March 12, 1788, Wightman left his house on Queen Street and stopped at a nearby tavern. The tavern stood at the Meeting Street cattle gate that separated Charleston from the shantytowns and pastures near where the College of Charleston now stands. Just down the street was

another tavern run by Thomas Jones, a place frequented by "thieves and killers."

Wightman's brother and some friends came looking for him, and Wightman told them to return to their shop at Broad and Meeting. "I'll be leaving shortly and I'll catch up with you," he said. But he never did. They found him later that night, slumped near the cattle gate, shot dead. A pistol lay nearby.

The police had already been called that evening to Jones's cattle gate tavern on another matter—to find some Dutch coins stolen from a sea captain. But until a posse of Wightman's friends and relatives showed up, the police hesitated to enter the den of thieves and killers.

The next morning, the bloody spot where Wightman died attracted a good share of sightseers. One of those sightseers solved the murder and was immortalized on the dead man's tombstone, not by name but by description: "The young son of Edgar Wells, a merchant." The boy found a coat button scuffed into the dust of the street—a button that matched the cloak of one of the tavern-goers, the same man charged with stealing the sea captain's coins.

Following the Revolutionary War and before a formal government was established, Charleston had a reputation for lawlessness. The whippings, brandings and hangings that followed the capture of the Jones's tavern gang didn't stop the siege of Charleston by ruffians, but for a time it

did reduce the number of arsons and highway robberies carried out in the area by "footpads."

Wightman's grave marker is weathered and, except for Wightman's name and the word "murderer," is almost unreadable. The engraving told the story as follows:

To the Memory of
Nicholas John Wightman
Who was killed by a Footpad
on the Night of the 12th of March, 1788.
Aged 25 years.
Peacably returning home
to his Brother's house
where he resided,
The Villain met and made an attempt
to rob him, which he resisted
and was instantly shot dead on the spot.

The description is continued on a square stone:

His Brother, with but small assistance
the same night, secured the murderer
and six accomplices, being the whole of a gang
that then very much infested the peace of the City,
and by their frequent Robberies,
and attempts to set fire to houses,
kept the inhabitants in constant alarm.

They were shortly tried, and upon the fullest
conviction,
Condemned and Executed.
Divine Providence ordered it so that a single button,
belonging to the coat of the murderer,
found on the spot where the murder was committed,
by a child, a son of Mr. Edgar Wells, Mercht.,
served, with other proofs, to discover and convict
him.
This Marble is erected, by an affectionate Brother
& Sister,
in memory of the virtues of their dear Brother,
who was beloved by all who knew him.
He was mild and affable in his manners,
Just, Generous, and Humane.
He is loved with the sincerest affection.
His soul rests at the Mercy Seat of his Creator.

St. Philip's is the home of ghosts as well as murder mysteries. Perhaps the graveyard's most famous specter is the Gray Man. He is usually seen leaning or sitting against one of the markers, staring, his peculiar pale-colored eyes locked on the steeple of St. Philip's.

Some believe he is the spirit of a slave named Boney who won his freedom in the late 1790s by saving the older, brick version of St. Philip's from sure destruction. Boney spotted a burning shingle on the roof, scaled the

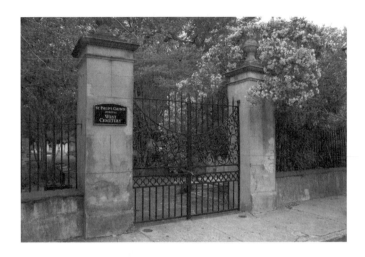

Above: Gates to St. Philip's graveyard. To the right of the gates lies a gravestone that solves a murder. *Courtesy of Tyler LaCross.*

Left: Wightman gravestone. Grave of a victim of a "footpad." *Courtesy of Cathy Pickens.*

Opposite: Wightman gravestone. *Courtesy of Tyler LaCross.*

brick wall and put out the fire before it could spread. His master gave Boney his freedom as a reward, but from then until he died, St. Philip's seemed to hold Boney in its spell. He would sit almost every day in the cool shadow of a leaning grave marker and stare. Some say he still sits, but you only see him when he's come to warn you.

A Gray Man has been seen in this part of St. Philip's Cemetery—but only by those to whom death will pay a visit very soon. Margaret Rhett Martin tells the story of a girl who, on a dare from her friends, agreed to go at midnight to the darkest part of the cemetery, to the tallest leaning tombstone where the Gray Man is commonly seen. She was to stick a walking cane into

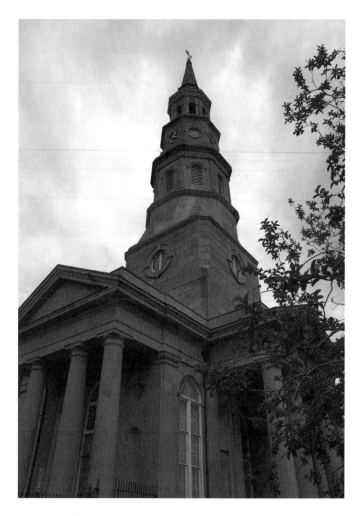

St. Philip's Church steeple. A former slave saved the church from burning. *Courtesy of Tyler LaCross.*

the ground as proof that she'd actually ventured that far into the graveyard. Her friends found her later that night, slumped in a heap at the base of the stone. The cane had pinned her flowing skirt to the ground, making it impossible for her to run from whatever frightened her to death.

It may be only a story, but be careful if you decide to wander through here late at night. Keep your eye out for a shadowy man near a leaning tombstone or a young girl in a long gown with a rose in her hair.

Exit gates opposite St. Philip's; turn right onto Church Street.

4. PIRATE HOUSE, 145–147 CHURCH STREET

The building next to St. Philip's Cemetery boasts its own dark heritage. Stories claim that these thick walls once housed secret meetings between Charleston merchants and pirates come to do business.

Whether they frequented this particular house may be only legend, but Charleston was a favorite haunt of pirates, for the city offered them both business and pleasure. Some Charleston merchants were willing to buy stolen goods; because of blockades, goods were scarce and could only be obtained from smugglers or pirates. The pirates brought not only scarce goods but

also plenty of gold and coins to spend in the brothels and taverns of this open port city.

Pirates roamed the North and South Carolina coasts for over one hundred years. The early 1700s witnessed the best-known "infestation" of pirates. Another outbreak of pirating, or "patriot privateering" as some called it, followed the outbreak of the War of 1812, but the eighteenth-century pirates were the most colorful and made the most lasting impression on Charleston.

Captain Edward Teach—more dramatically known as Blackbeard—frequented this port. Known as a vicious and treacherous pirate, he understood the high drama of pirating: before attacking a ship, he would tie slow-burning

Courtyard at the Pirate House. *Courtesy of Tyler LaCross.*

The Pirate House. *Courtesy of Tyler LaCross*.

fuses into his beard. The smoke snaking around his bushy beard and fierce face created a memorable impression on his victims—at least those who lived to tell about it.

Charleston's homegrown pirates were an unusual and mixed lot. Richard Worley captured his first prize using only a small longboat and muskets. William Fly was a pirate for only a month, but he managed to make a name for himself by plundering several ships off the coast before he was captured. William Lewis had a much longer career—too long, according to his crew. They murdered him in his sleep because they felt he was "too intimate with the Devil."

For more pirate stories, see #6 and #15.

5. DOCK STREET THEATER, 135 CHURCH STREET

Charleston boasts one of the oldest theaters in the United States, built on this site in 1735. (Queen Street was then called Dock Street because a creek cut through beside the theater.)

The dusty blue façade of the current building belonged to the old Planters Inn, which itself was built on the ruins of the older theater. The hotel was abandoned after the Civil War and was not restored until the 1930s. This singular blue color is called, in Charleston, "haint blue" because it is reportedly used by natives to ward off spirits. The theater has its share of unearthly residents, but their stories have been clouded by time. Are they leftovers from the early days of Charleston theater? Or are they guests who didn't want to leave the once-elegant Planters Inn? Perhaps no one has bothered to ask them.

Turn left on Chalmers Street.

6. THE PINK HOUSE, 17 CHALMERS STREET

The Pink House has stood on cobblestoned Chalmers Street since 1712. It is rumored to have housed a tavern popular with the pirates who once visited Charleston's brothel district. The cobblestones—made

The Dock Street Theater. Haint blue—and haunted? *Courtesy of Tyler LaCross.*

from ships' ballast—take you back to a time when pirates swaggered down these streets in search of repast and entertainment.

Charleston produced at least one female pirate: Anne Bonny grew up on a plantation near Charleston. She became known around town for her raging, furious temper and fits of violence. She ran away with a sailor—probably to her father's relief—and later joined with Captain Calico Jack Rackham's crew. Mary Read, another female pirate, later joined Calico Jack's crew as well (at first disguised as a boy). Anne was captured and

Chalmers and Church Street sign. The Pink House on Chalmers was once a brothel. *Courtesy of Tyler LaCross.*

Cobblestones on Chalmers Street.*Courtesy of Cathy Pickens*.

convicted of piracy, but what happened to her remains a mystery. Records do not show that she was ever hanged.

Charleston was the site of several pirate hangings: Richard Worley and his crew and Stede Bonnet (the gentleman pirate) and his crew were hanged at White Point Gardens. (Note: Colonel William Rhett, sent by South Carolina's Governor Robert Johnson to capture Bonnet, lived north of the Public Market at Hasell Street.)

Blackbeard was killed in a hard-fought battle off the North Carolina coast on November 22, 1718, and Stede Bonnet and his crew were hanged two and a half weeks later in Charleston. The glory days of pirates ended then, but tales of their buried treasure and earth-walking spirits are still alive.

Turn left on State Street, then right on Queen Street to East Bay. Cross East Bay for the best view.

7. WAGENER BUILDING, 161 EAST BAY STREET

East Bay Street at Queen Street is now a bustling commercial district with some of the city's best restaurants and bars within easy walking distance. However, when this beautiful corner building with its arched eyebrow windows was constructed in 1880 to house the enterprises of F.W. Wagener & Company, this was fronted by Charleston's bustling wharves. The retail portion on the lower floors sold groceries and liquor, while the warehouse and upper floors held the cotton and fertilizer brokerage. The towering windows provided light and ventilation, as well as an expansive view of the busy port.

The early fortunes of Charleston were not, as many suppose after reading or watching *Gone with the Wind*, built on cotton, but rather, on indigo and rice. However, by the late 1800s, cotton was growing in importance and influenced the fortunes of many firms and Charleston families, though not as one might expect. Cotton grew better in places away from Charleston, where it fed the now-booming textile industry in the Upstate, elsewhere in the South and in England.

What fed the cotton, though, came in abundance from Charleston: phosphate fertilizer from the rich deposits around Charleston helped grow bountiful crops of Carolina cotton. When the weather conditions are right, the pungent odor of phosphate still greets visitors to Charleston as they drive in on Interstate 26.

During the late 1800s, the Wagener firm became a profitable fertilizer broker, possibly thanks in part to John A. Wagener's term as mayor, during which time a bribery scandal developed over the granting of phosphate mining rights. Wagener was voted out of office, some say because his administration was corrupt; others say he was too successful at fighting corruption and made powerful enemies. He turned his attentions elsewhere and became the founding father of the Upstate town of Walhalla.

Prosperity and success rarely breed ghosts, and the prosperous and successful Wageners apparently went quietly and happily to their eternal reward, leaving no ghosts behind. Loss, tragedy and ruin are the more likely medium for inducing a spirit to stay behind, hoping perhaps to right the wrongs or undo a tragedy in some way. It was a client of the Wagener firm who became one of those doomed to remain behind, trying to cling to the remnants of the family fortune he lost.

According to research by Edward Macy and Julian Buxton III, George Poirier was the ill-fated descendant

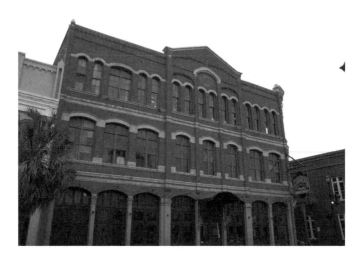

The Wagener Building. An unsuccessful businessman saw the end of his troubles here. *Courtesy of Tyler LaCross.*

of a wealthy, aristocratic family. The family fortune had survived the Civil War, likely because the Poiriers did what many other savvy planters and merchants did—they supported the Confederate effort but invested in Northern and British interests. However, as is sadly and often the case, the sons and grandsons did not inherit talented business minds along with their money. George Poirier had not been able to hold onto his family's fortune.

The story is that by 1885, George had only one last financial gamble left in him. Soil depletion and army worms had attacked the Carolina cotton crop with a

Wagener Building close up. *Courtesy of Tyler LaCross.*

vengeance, and George was able to salvage only one last shipment of cotton, the sum of all his wealth. He hoped to sell the cotton and invest in the phosphate boom, thereby recouping enough to pay his creditors and start life again.

Perhaps we don't hear stories of successful last gambles because bad news is more interesting. Or perhaps only failed gambles make good ghost hauntings. In any event, George's last gamble didn't have a happy ending. From the third floor window of the Wagener Building, he watched as the ship carrying his cotton steamed out of the harbor. He could also see the first whiffs of smoke

from the ship, then the lapping flames consuming the ship as the crew leapt into the water. He watched his dreams sink in smoke and flame into the gray water of Charleston Harbor.

It was left to someone else's son to witness the next scene in the drama. The following day, from the street below, a passerby saw the figure of a man swinging from the rafters in the upper level of the Wagener Building. The scavenger birds that usually scoured the dock area for food had entered the open windows and found George Poirier before anyone else had.

Fortunes are made and lost, but the tragedy of losing a fortune tends to bind some to earth more tightly than others.

Continue south on East Bay to Broad Street.

8. EXCHANGE BUILDING AND PROVOST DUNGEON, 122 EAST BAY STREET

The Exchange Building balcony has appeared in several movies and television commercials, but the dungeon is the place that houses history. Charleston's signers of the Declaration of Independence were once imprisoned in the vaulted brick dungeon under the Exchange Building, as were pirates and prostitutes. Former prisoners include Colonel Isaac Hayne, whose hanging by the British in

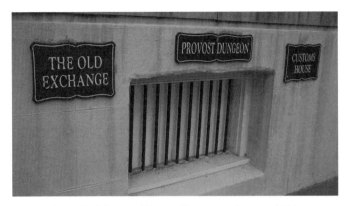

The Exchange Building and Provost Dungeon. *Courtesy of Tyler LaCross.*

1780 prompted a Patriot uprising (see tour stop #14), and Stede Bonnet, Charleston's gentleman pirate (see tour stop #15). Unbeknownst to the Brits during the Revolution, General William Moultrie had secreted ten thousand pounds of gun powder in the building, never discovered by the occupation forces.

The dungeon was abandoned until a few decades ago, when it opened for tours. Its history of entertaining some of Charleston's finest—and worst—in worse-than-deplorable conditions makes it inevitable that at least some of the dungeon's unfortunate inhabitants still remain. If you decide to tour the dungeon, don't lag behind your group to study that wax mannequin lying on the floor. And if you stroll by on the sidewalk on a dusky

evening, don't be startled by noises from the dungeon. It may just be the cleaning crew.

The shop across Exchange Street at 120 East Bay has a close view of the barred dungeon windows. This was the Old Carolina Coffee House, long before Starbucks popularized the modern version of a coffee house. Even though it's unclear whether this is the original building, the coffee house on this spot was a meeting place where pre–Revolutionary War intrigues were plotted.

Continue one block south on East Bay; turn right on Elliott Street and left on Church Street.

9. CABBAGE ROW, 89–91 CHURCH STREET

DuBose Heyward, who lived nearby, used this building as a model for Catfish Row in the novel that later became Gershwin's opera *Porgy and Bess*. "Porgy" was a small fish sold door to door by African American peddlers. One sing-song Gullah chant preserved in the WPA history of South Carolina went: "Porgy walk, porgy talk, porgy eat wid knife and fawk; porgie-e-e."

The model for the Porgy of opera fame was a Charleston character named Samuel "Goat Sammy" Smalls, a crippled man who sold candy and peanuts from a goat cart near city hall. Goat Sammy seems to have had trouble with the women in his life. His

Old Carolina Coffee Shop, 120 East Bay Street. Did revolutionaries meet here, in earshot of the provost dungeon? *Courtesy of Tyler LaCross.*

name appears on Charleston's police blotter more than once: he wounded one woman and attempted to shoot another one.

Goat Sammy died in 1924, never knowing of his lasting fame as Porgy. Don't look for him here at Cabbage Row, though: he's buried "crossways to the world" on James Island. But stand a moment in the shadows near city hall, at the corner of Meeting Street and Broad, and you may hear a creaking wooden goat cart and hear his faint cry: "Peanuts, a nickel."

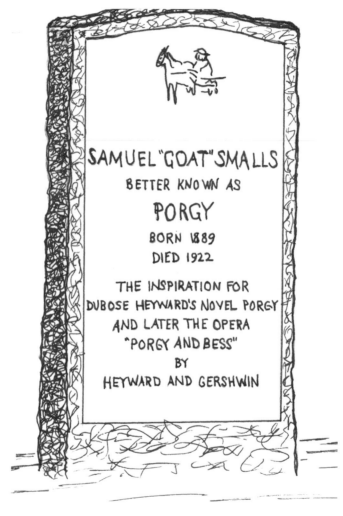

Goat Sammy's gravestone on James Island. *Courtesy of Cathy Pickens.*

Rainbow Row on East Bay, sometimes mistaken for Catfish Row of *Porgy and Bess* fame. *Courtesy of Cathy Pickens*.

10. THOMAS ROSE HOUSE, 59 CHURCH STREET

Dr. Ladd, the whistling doctor, can still be heard climbing the staircase of Misses Fannie and Dellie Rose's old Church Street home. Whether he haunts the house because of the loss of a love or the loss of a friendship is not known. The gentle poet/doctor came from Rhode Island in the late 1800s to set up practice. He roomed with the Rose sisters because, following the War Between the States, rooms were scarce in the war-damaged city and money was scarce for the Rose sisters.

Soon after his arrival in Charleston, Dr. Ladd was befriended by a man named Ralph Isaacs; but as the

doctor's practice and social standing improved, Isaacs became jealous. One evening, the two men attended a performance of Shakespeare's *Richard III* at the Exchange Building. (The old Dock Street Theater had burned a few years earlier.) A wild, irrational argument started over the merits of the performance of a Miss Barrett, one of the young actresses. By all accounts, her performance had been dismal, but Dr. Ladd persisted in finding good things to say about her.

Over the next few weeks, Isaacs's attacks on Dr. Ladd's character became so open and vindictive that Dr. Ladd wrote a letter to the Charleston *Gazette*: "I account it one of the misfortunes of my life that I became intimate with such a man." Isaacs fired back a letter to the editor, calling Ladd "a self-created doctor" and "as blasted a scoundrel as ever disgraced humanity."

The jealousy and ill will grew until Isaacs demanded a duel. As the two men faced each other at the appointed time, Dr. Ladd fired his pistol into the air, refusing to shoot the man who had been his friend. Isaacs, however, was not possessed of so beneficent a spirit. He took careful aim and fired twice, hitting Ladd below the knees, intending to cripple him for life. Dr. Ladd's friends carried him back to the Rose sisters' house, where he lingered, feverish, for three weeks before he died.

While on his deathbed, he continued to pen poetic pleas to Amanda, the girl he had left in Rhode Island.

One verse read:

> *Soon the grim angel will restore my peace,*
> *Soothe my hard fate, and bid my sorrows cease;*
> *And tear Amanda's image from my breast.*

[From The Literary Remains of Joseph Brown Ladd, M.D., *by Elizabeth Hawkins (Clinton Hall, NY: Sleight, 1832).]*

He has been heard whistling on the stairs at 59 Church, just as he used to do in the evenings when he went upstairs to write poetry and dream of seeing Amanda again.

Turn right on Water Street, then left on Meeting.

11. Murder of Mrs. John Ravenel, Meeting Street at Water Street

The day after Halloween, 1933, two unrelated but sensational murders occurred—the ice pick murder on Market Street (see tour stop #1) and, even more famous, the mysterious murder of Mrs. John Ravenel, whose body was found, shot, on Meeting near Water Street. Her murderer has never been found.

Mrs. Ravenel had dined that evening with a friend at the Fort Sumter Hotel on the Battery and was walking to

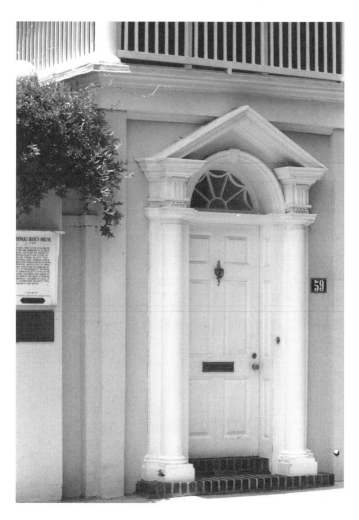

59 Church Street. A doctor killed in a duel returns to his lodgings.
Courtesy of Cathy Pickens.

her 12 Tradd Street home about 9:30 p.m. About 10:00 p.m., she was found by two women passing in a car. She was conscious, lying on the sidewalk. Her only words were, "A man hit me," and at first they thought she'd been struck by a car. She was taken to Roper Hospital, where she died of a chest wound from a .38-caliber hand-filled copper-jacketed bullet.

Theories at the time suggested that someone shooting at a cat accidentally hit her; that she'd been the victim of an attempted robbery (the bullet passed through her forearm as if she'd thrown her arm up to protect herself); that someone had put a bullet on the streetcar track as a prank (but no spent shell was found); or that she'd been shot from a passing car (but the angle was wrong, and a neighbor reported hearing running footsteps).

Mrs. Ravenel's first husband had been a wealthy plantation owner; her second was the son of socialites Dr. and Mrs. St. Julian Ravenel. Naturally the case attracted much police attention. Stories have it that, for years afterward, Chief of Detectives John J. Healy fired every gun that came into police custody in an attempt to find the murder weapon.

One of the most unusual twists on the story came five years later. In September 1938, two tornadoes devastated Charleston, killing twenty-nine people. During the cleanup, a gun was found under an overturned filing cabinet in a photographer's home—a .38-caliber pistol with hand-

Left: Meeting Street. Along this peaceful street occurred one of Charleston's most mysterious unsolved murders. *Courtesy of Tyler LaCross.*

Below: 39 Meeting Street. A house "literally full of specters." *Courtesy of Tyler LaCross.*

Opposite: 37 Meeting Street. Did pirates bury their booty in the backyard? *Courtesy of Tyler LaCross.*

filled copper-jacketed bullets, found in the home of a man Mrs. Ravenel had once offended by calling him "effeminate." The gun was so badly water-damaged that it couldn't be test-fired.

The case remains unsolved.

12. 37 AND 39 MEETING STREET

Not much is known about the spirits who inhabit 39 Meeting Street, except that an Episcopal priest who once lived there reported plenty of them: the house is "literally full of specters," says one account.

At 37 Meeting Street, also known as "the Bosoms" because of its unique bowed front, the ghost doesn't live in the house at all, but rather in the backyard. The marshy reaches of Vanderhorst's Creek once lay just below where the house stands.

One evening, a pirate crew paddled a dinghy up the creek and buried a chest of treasure just above the marsh. Later, when the pirate captain found one traitorous scalawag had snuck back to dig up the chest, he shot him and left his bones to guard the treasure. The pirate's ghost must have done his job, because no one has ever found the treasure. Plenty of Charleston children have dug up the backyard searching for it—but they never dig at night.

13. DANIEL HUGER HOUSE, 34 MEETING STREET

Walk carefully by this house. Maybe you'll want to stay on the far side of the street. At least twice in its history, the house itself has tried to kill someone—and once it succeeded. Francis Huger was almost killed by a bull's eye (an ornamental fixture) falling from the roof. By one account, his cousin Mrs. Huger saved his life following the accident by refusing to let him be trepanned (at the time, a popular treatment for skull fracture that involved cutting a hole in the skull).

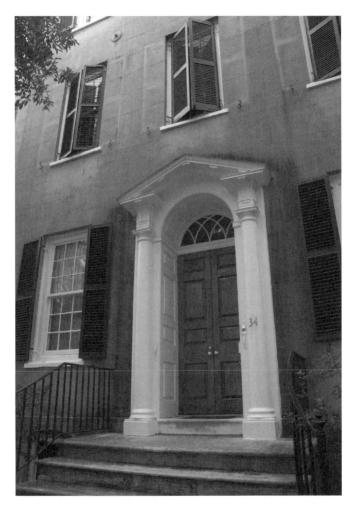

The Huger house, 34 Meeting Street. Beware! This house has killed before. *Courtesy of Tyler LaCross.*

A few years later, during the massive earthquake of 1886, the piece that had replaced the fallen bull's eye fell and "crushed an unfortunate young Englishman" who was visiting and who, frightened by the earthquake, rushed out of the house to his death.

14. PERRONEAU HOUSE, MEETING STREET AT ATLANTIC STREET

The ghost of Revolutionary War hero Isaac Hayne used to return to the Perroneau house, keeping a promise he made to his sister-in-law, Mrs. Perroneau. The British occupied Charleston, and Lord Rawdon was determined to make an example of the popular Colonel Hayne, a leader of the rebellious Charleston Patriots. Hayne was captured and imprisoned in the infamous Provost Dungeon, summarily tried and sentenced—not to die a prisoner of war's death before a firing squad, but to die a traitor's death at the end of a hangman's rope.

According to one story, on his way to be hanged, Hayne was led past Mrs. Perroneau's house, where his two small sons were staying. Standing at the window on the north side of her house, Mrs. Perroneau cried out, "Return to us!"

"I will if I can," he called back. He died with courage, his death igniting a local uprising against the British. And he did return to Mrs. Perroneau's. For many years, a voice

could be heard calling from the street. Some have even heard his footsteps running up the stairs, coming home to his sons and family.

Continue south on Meeting to White Point Gardens and the Battery.

15. WHITE POINT GARDENS

(A) Stede Bonnet

Take a seat on one of the benches, enjoy the sea winds and smells and the crunch of tabby (crushed shells) underfoot. But White Point Gardens was not always a pleasant park. The harbor and the houses that face it have seen the comings and goings of centuries of mystery and mayhem.

White Point was, at one time, a low, marshy area where pirates were hanged and buried below the water line—a fitting end for pirates and a warning to others who would follow in their path. Stede Bonnet, Charleston's gentleman pirate, met that fate here. Bonnet was a member of Charleston society and one of the most unusual pirates to pillage this coast. He reportedly left Charleston to escape a nagging wife, and—to the bemusement of other pirates—used his own money to buy and outfit his pirate vessel, *The Revenge*; he even paid wages to his pirate crew. At first, he routinely set his victims adrift rather than

Left: White Point Gardens. *Courtesy of Cathy Pickens.*

Right: Monument to Charleston's hometown pirate, Stede Bonnet. *Courtesy of Tyler LaCross.*

kill them, which was the brutal custom of most pirates. But Bonnet abandoned his gentlemanly manners and learned ferocity and cruelty when his own ship was commandeered by Blackbeard, the most treacherous pirate to run these waters.

Bonnet was finally captured in 1718 by Charleston's Colonel William Rhett after a blazing battle off the North Carolina coast. Bonnet was imprisoned in the Provost Dungeon and hanged on a chilly December day at White Point, just southeast of where 4 South Battery now stands.

A stone monument across from the house commemorates the event.

(B) Theodosia Burr

Pirates played an important role in another of Charleston's finest families. The nearby Edmondston-Alston house (21 East Battery) was home to the Alston family. Their family ghost reportedly haunts a beach north of Charleston near Murrell's Inlet and Magnolia Beach (now Litchfield Beach).

Joseph Alston met and fell in love with young Theodosia Burr, the much-loved daughter of Aaron Burr. Theodosia was beautiful and talented and had been the center of her father's life and the toast of his influential friends. She married Alston, and on their honeymoon, they visited Washington to see Thomas Jefferson and her father inaugurated as president and vice president of the United States.

Theodosia had trouble adjusting to the quiet life and the humid, fever-filled climate of her new plantation home. In 1812, devastated by the death from fever of her ten-year-old son, Theodosia decided to sail to New York to meet her father. (He had been tried and acquitted on treason charges and was returning from a stay in Europe.)

Theodosia set sail from Georgetown, South Carolina, on December 31, 1812. Sea travel was thought to be safer than overland travel, despite the outbreak of the War of

1812 and renewed pirate activity along the Eastern coast. Alston, now governor of South Carolina, was to join her later in New York.

Her ship, the *Patriot*, never arrived in New York. Aaron Burr launched an extensive search, but no sign of the *Patriot* was ever found. Joseph Alston mourned his missing wife. Unable to concentrate on his duties as governor, he would sit for hours in Theodosia's bedroom at their plantation home and grieve. Three years later, he took ill and died.

Theodosia's fate raised more questions several years later when, in a deathbed confession, an old pirate told of a beautiful, spirited, courageous young woman who was onboard the *Patriot*, captured by pirates off the North Carolina coast. The pirates had forced her to walk the plank.

Along the coast near her plantation home, Theodosia's ghost has been seen suspended over the water, arms outstretched, just as the dying pirate described her brave walk off the plank into the cold Atlantic waters. Is she searching for her son and her husband? Taking one last look at the Carolina coast she found so difficult? Or warning those who see her of unseen dangers in the Atlantic waters?

We may never know why, but she certainly comes. Ask any of the old fishermen who work south of Murrell's Inlet—they can tell you.

The Walking Tour

(C) Battery Carriage House Inn, 20 South Battery

Entire books have been written on inns purported to be haunted. Most inns would be content to have one such haunting; more than one might be unseemly, even greedy. The Battery Carriage House Inn can indeed boast two ghosts—two ghosts with decidedly different personalities.

Room 10 is the purview of the Gentleman Ghost. He is reportedly the revenant of a young man who returned home from Yale, perhaps bringing with him a broken heart. In 1904, he fell—or jumped—from the top of the mansion's roof, dying in the garden below.

His appearances have never been threatening. In fact, he has a fondness for female guests, sometimes climbing in bed with them but always acting in a most gentlemanly fashion, disappearing when his bedmate awakens and screams. He may be chivalrous, in a manner of speaking, but he's never been described as a heartthrob: dressed in Victorian-era clothing, he's said to be short and balding.

The specter in Room 8 has never been called a gentleman, although that may not be quite fair. People report a sense of menace, but that may be because the poor fellow has no head. Most descriptions say he's thick-chested, dressed in homespun clothing, perhaps a uniform, but they can offer little more. Some report a cold sensation or the sound of wind. He stands by the

bedside—not brazen enough to lie down with a visitor, as the more forward gentleman in Room 10 does—and he grunts or rasps or wheezes in an angry way. He too disappears through the wall once he's finished making the guest's hair stand on end.

Many speculate that this ghost may have stayed behind after helping destroy Confederate ordnance stored along the Battery as the Confederates evacuated the city ahead of the arrival of Union troops. That could explain why no one has seen his head or limbs during his nighttime visitations, and why he sounds a bit disgruntled.

(D) News *Editor's Murder*
Another house not too far from the Battery (101 Rutledge Street) was the scene of a scandalous murder. In the afternoon of March 12, 1889, Captain Dawson, editor of the Charleston *News & Courier*, was shot and killed in the home of young Dr. McDow. The testimony during the sensational trial that followed set Charleston buzzing with whispers of a Victorian sex scandal.

Captain Francis Warrington Dawson stormed into Dr. McDow's office that March afternoon, threatening McDow with both his cane and his power in the community. Dawson was upset over the doctor's attentions to Dawson's young Swiss governess. The argument was a mismatched one: Dawson was a distinguished Confederate veteran and well known in Charleston, a large and imposing man;

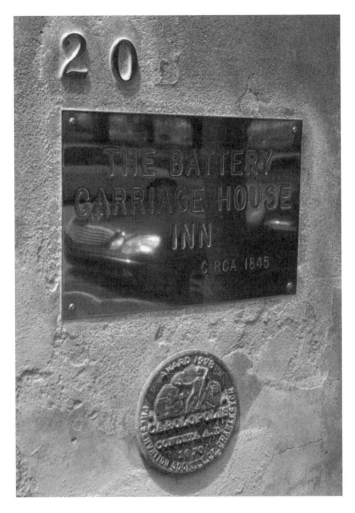

Battery Carriage House Inn sign. Two ghosts call the rear carriage rooms home. *Courtesy of Tyler LaCross.*

Battery Carriage House Inn front view. Did an unhappy young man fall—or leap—to his death? *Courtesy of Tyler LaCross*.

McDow, short and slightly built, was a newcomer and an outsider, married to a wealthy German woman.

According to McDow, Dawson's beating and berating left McDow with no choice but to pull his pistol and fire. It took more than an hour for Dawson to breathe his last.

An immediate confession may have kept this case from becoming one of Charleston's most talked-about trials. But Dr. McDow first tried to cover up his crime by burying Dawson's body in the sand beneath his outside stairway. When he had difficulty digging the hole deep enough, he thought better of his actions. He dragged the body from the hole and tried to dust the sand from Dawson's hair

and clothes. Then, three hours after the shooting, McDow confessed to a policeman on the street.

Ironically, another policeman, who knew of Captain Dawson's concerns about his governess's honor, had received word that afternoon of a single pistol shot on Rutledge Street. Fearing trouble, he went immediately to McDow's door, but was told that nothing was wrong. At the time, of course, McDow must have been locked in his ground-floor office with the dead or dying Captain Dawson.

The trial was a circus. Rumors had circulated about Captain Dawson's own affections for his children's governess. Marie Burdayron, "the lady in black," the tiny attractive Swiss woman at the center of the murderous argument, testified that McDow, a married man, had given her a gold watch and paid her many attentions. She had loaned him a scandalous novel, *'Twixt Love and Law*, about a single girl's love for a married man. After a long, sweltering trial, the jury deliberated only two hours. When the jury declared McDow not guilty, the spectators cheered.

The debates over the surprise verdict finally died until a few years later when, on a hot summer day, Dr. McDow's dead body was discovered in his home on Rutledge Street. Some say the specter that visits 101 Rutledge is Dr. McDow, but others claim it is Captain Dawson. Maybe both are inside, locked in a continuing battle for

Left: 14 Legare Street. Does an unhappy ghost couple still ride this street? *Courtesy of Tyler LaCross.*

Opposite: 15 Legare Street. When a shot in a duel was fired from the third-floor window, the man in 14 Legare fell dead. *Courtesy of Tyler LaCross.*

the affections of a twenty-two-year-old governess with a charming accent.

Continue west on South Battery; turn right on Legare Street.

16. SIMMONS-EDWARDS HOUSE, 14 LEGARE STREET

This block of Legare Street has more than its share of ghosts, and this house has more than its share of stories. The house was built by Francis Simmons, a wealthy planter who married a Charleston woman but never lived with her

(see tour stop #19). The house was later owned by George Edwards, who erected the pine cone (mistakenly called pineapple) gates. Whether Edwards and his wife actually had marital problems or whether his story was confused with Simmons's is unclear, but whoever they are, a pair of ghosts have been seen on this street, walking hand in hand toward this house.

Reportedly, Mrs. Edwards lived in a cottage down the street for several months after the Edwards's marriage. Then Mr. Edwards began visiting the cottage late at night. Sometimes, around midnight under a full moon, you may see a shadowy couple walking slowly down Legare Street toward number 14.

The house has more than one ghost—and a blood-stained floor that for many years would not come clean. A dueler, Mr. Lowndes, stood in the third-story corner window across the street at 15 Legare. The other dueler, his cousin, stood in the third-story corner window here at 14 Legare. They fired, and the man in 14 Legare fell, bleeding and fatally wounded.

As you move down the street, don't look too closely at those third-floor windows. Someone may be looking back.

17. 31 LEGARE STREET

This elegant white house looks out of place in Charleston. The wide porches facing the street give it an Upcountry look, but inside the house lives a uniquely Charleston ghost, reportedly "one of the most tragic and quietest spooks on record," according to a *Post-Courier* booklet.

Mrs. William Heyward built the house after the death of her husband and raised her three children here. Her youngest son, James, had fought in the Revolutionary War. He liked books and was known as a studious young man. The second-floor library on the sunny south side of the house was his favorite room.

One morning his mother walked into the library and was startled to find him sitting at the desk wearing his

31 Legare Street. A silent ghost returns to the second-floor library.
Courtesy of Tyler LaCross.

hunting coat, his head bowed in his hands. He had left that morning to go hunting at a rice plantation outside town.

When she spoke to him, he disappeared!

Later that morning, men arrived at the house carrying James's body. He had been killed in a shooting accident at the exact moment Mrs. Heyward saw him sitting in the library.

James has returned to the house over the years to visit his beloved library. He's always seen sitting, his head in his hands, and he always politely disappears as soon as someone enters the room.

18. THE SWORD GATES, 32 LEGARE STREET

The imposing wall and ornate gates surrounding the former Madame Talvande's School for Girls have, by all accounts, done their job.

Maria Whaley, fifteen years old, was sent to Madame Talvande's after she had taken a fancy to Mr. Morris, a young Yankee visitor. When Maria's father arranged to have the young man's stay at a neighboring plantation cut short, the persistent young man pitched a tent near the Whaley plantation so he could be near Maria.

The courtship apparently continued after Maria was shipped to Madame Talvande's. One night, Maria escaped

Opposite: The Sword Gates. The gates were built too late to prevent a Charleston girl from marrying a Yankee. *Courtesy of Tyler LaCross.*

Right: Gateposts at 131 Tradd Street. A ghostly carriage can be heard coming down the street toward these gateposts and home. *Courtesy of Cathy Pickens.*

over the wooden fence that surrounded the school, married the Yankee and then snuck back into school. Mr. Morris arrived a few days later to call for his wife, and Madame Talvande almost swooned in panic. The high wall went up to prevent further elopements. (The well-known Sword Gates were added by a later owner.)

Madame Talvande has been seen wandering the halls late at night, her handkerchief clutched nervously in her hand, checking the rooms to make sure none of her young charges have made it over the wall.

Turn left on Tradd Street.

19. GATEPOSTS, 131 TRADD STREET

The brick columns at the alley entrance are all that remain of the home of Ruth Lowndes Simmons. She married Francis Simmons, an eligible Johns Island plantation owner, and lived the rest of her life in their home—alone. Ruth is supposed to have tricked Francis into marrying her and, rather than violate his strict code of Southern honor, Francis married her in name but never in fact. He later built an elegant home for himself at 14 Legare (see tour stop #16).

Francis and Ruth gave lavish parties at her Tradd Street home, but Francis never stayed after the guests left. Whenever his carriage passed Ruth's on the city streets, they stopped, stood and bowed formally to one another before continuing on their very separate ways. After a lifetime of this strange arrangement, he died alone at his home at 14 Legare.

If you stand close to the gateposts, even on the hottest summer day, you'll feel an unexpected coolness. On moonless and lonely nights, residents say you can hear a ghostly carriage rolling down the alley taking Ruth Simmons back to her home. While the house was still standing but long after she had died, people reported seeing her sitting at her bedroom window, alone, waiting...

Retrace your steps and continue east on Tradd Street.

106 Tradd Street. General Francis Marion was here—plotting a revolution, or just playing cards? *Courtesy of Tyler LaCross.*

20. JOHN STEWART HOUSE, 106 TRADD STREET

The bright, cheery exterior of this house belies the dark stories told about it. Late at night, particularly when the fog is heavy, a carriage can be heard rolling up in front of this house, the horse's hooves thudding heavily on the paving stones, the leather harnesses creaking softly. Does the carriage come to pick up the Swamp Fox Francis Marion, the Revolutionary War hero who once leapt from a window of this house to escape a British patrol? Or was he escaping an unfortunate hand of cards, as some report? Or does it come to pick up someone else? No one knows—or at least no one is telling.

21. WALLED GARDENS

As you walk, note some of the spectacular backyard gardens and European-style courtyards hidden behind brick or stone walls and guarded by massive iron gates. Some of these idyllic gardens hide secrets of murder and mayhem. Amateur and professional archaeologists have excavated privies in gardens all over the city. As an example, the Thomas Elfe workshop (54 Queen Street) displays pottery found in the workshop's privy, similar to the pottery, bottles, tools, buttons, jars, gold coins and other items found in other privies.

Left: A quiet garden. In some Charleston gardens, evidence of murder has been uncovered. *Courtesy of Tyler LaCross.*
Right: A hidden courtyard. *Courtesy of Tyler LaCross.*

But some privies have held darker secrets. In an old privy on Pinckney Street, searchers found a pistol and a human skull with a bullet-sized hole in it. No other human bones were unearthed—just the skull. The excavator surmised that the body may have been disposed of in the marshes and the head hidden in the privy to prevent identification. The victim is still unidentified.

In another backyard privy, searchers uncovered two human jawbones. A medical examination determined

that they belonged to two teenagers and could have been buried for more than one hundred years. Nothing more is known about the supposed murder case.

Who knows what other mysteries lie buried in the elegant gardens of other Charleston homes?

Continue east on Tradd Street; turn left on Meeting Street.

22. St. Michael's Rectory, 76 Meeting Street

The quiet, white frame house that overlooks St. Michael's Churchyard also overlooks a narrow, shadowed street: St. Michael's Alley. A duel fought in the alley provided the

Opposite: St. Michael's Rectory. Multiple ghosts have been heard carrying a duel victim to his deathbed. *Courtesy of Tyler LaCross.*

Right: St. Michael's Alley. *Courtesy of Cathy Pickens.*

house with its resident ghost. Friends of the duel's young victim carried him into 76 Meeting Street and he died there from his wound. For decades, residents heard the duelist being carried up the stairs to his third-floor room, thump, thump, thump—though no one has reported hearing the sounds of a body being carried since the house became a rectory in 1942.

In the late 1700s and early 1800s, the house was home to Judge Elihu Bay, the judge who sentenced Lavinia Fisher, South Carolina's first mass murderer, to hang (see tour stop #24). One of Judge Bay's many eccentric sentences was given to two men charged with biting: he sent them to the same cell and told them, "You may bite one another as much as you like."

23. ST. MICHAEL'S CHURCHYARD

Graveyards, especially ones as old as Charleston's, have much mystery to protect. At St. Michael's, the church itself was the site of a mysterious tragedy. The facts have become shrouded and confused in the mists of time, but the church itself may be visited by the ghost of a bride poisoned in the early 1800s. Some reports say Harriet Mackie collapsed and died at the altar during her wedding ceremony. Others say she was taken ill and died during her honeymoon. Some claim she was poisoned out of jealousy.

If she was murdered, who is guilty? The stories are hazy. The mystery itself is shrouded in mystery, but Harriet, the poisoned bride, is buried in St. Michael's Churchyard. (Her story provided the basis for Susan Petigru King's book *Lily*.)

24. COUNTY COURTHOUSE, MEETING STREET AT BROAD STREET

In 1819, the county courthouse was the site of one of South Carolina's most infamous murder trials. The crime itself was not so unusual for that time: highway robbery and murder. The waylaying and killing of travelers on the desolate roads leading into Charleston were not

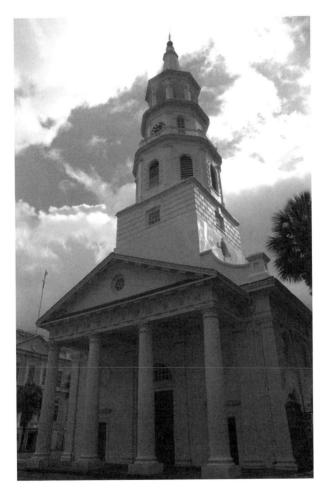

St. Michael's Church. The churchyard may be the resting place of a woman tragically poisoned on her wedding day. *Courtesy of Tyler LaCross.*

encouraged, but also were not uncommon. The murderers, not the murders, made this trial noteworthy.

Lavinia Fisher has been called South Carolina's most famous mass murderer—although only two bodies were found buried near Six Mile House tavern (located north of Charleston where Old Dorchester Road crosses Goose Creek Road at Ashley Ferry). Other gangs of highwaymen prowled the north roads, preying on Upstate trappers and farmers bringing goods into Charleston. But unlike run-of-the-mill highwaymen, Lavinia earned a spot in Charleston legend.

By all accounts, she was tall and strikingly beautiful, though no one describes whether she was fair or dark. Her husband John was tall and handsome, and together they commanded a ruthless band of ruffians. Lavinia, the most ruthless of all, dispatched her victims by poisoning their breakfasts. Another tale—but unsupported—tells of a collapsing bed that dumped bodies into the tavern basement.

On February 18, 1819, mounted vigilantes rode out to capture the notorious Fisher gang. Not knowing which tavern housed the gang, the posse mistakenly burned Five Mile House and then proceeded to Six Mile House, where the Fishers and others were captured.

They were jailed in the old Magazine Street Jail until their trial and hanging. Judge Elihu Bay—a colorfully eccentric jurist, elderly, deaf and beset by a painful

The County Courthouse. A mass murderess was sentenced to death in this courthouse. *Courtesy of Tyler LaCross.*

stutter—presided at the trial. (Judge Bay lived in the house adjacent to St. Michael's Churchyard, now the rectory. See tour stop #22.)

Lavinia, ruthless in life, was not brave in the face of the hangman's noose. She and John used every delaying tactic available—even gaining a respite from the governor to give them a few extra days to "meet their God." Dr. Richard Furman—Furman University

is his namesake—prayed daily with the Fishers and even walked with them to the gallows.

The ladies of Charleston rallied to Lavinia's cause, petitioning to spare her. But in the end she was dragged screaming and cursing onto the gallows built outside the city gates, where today Meeting Street turns onto the Cooper River Bridge. She screamed to the crowd, "If you have a message you want to send to Hell, give it to me—I'll carry it!" and carried herself into Charleston legend.

25. THE STREETCAR MURDER, MEETING STREET

Charleston is haunted by many stories of love gone wrong. The story of the McClures, while not as famous as *Porgy and Bess,* has its own poignant appeal. Late one chilly December night in 1936, Corrie Ethel McClure climbed onto one of the trolley cars that ran up and down Charleston's streets. A doll-like woman dressed all in green, she rode quietly with the other passengers, headed toward the end of the line. The trolley's motorman, Grover P. McClure, was understandably nervous when she boarded—he had gotten a court order forbidding Corrie Ethel from riding his trolley car.

McClure's fear of his wife proved well-founded. After the last passenger—Clarence Levy, age eighty-one,

billed as the world's oldest policeman—left the car, Mrs. McClure shot her husband dead, hopped from the trolley car, walked home and shot herself. Her dog, anxious to protect her, stood over her and prevented police from helping her for what seemed an interminable time. She died later that night at Roper Hospital, telling doctors and police that it was better if she and her husband both were dead rather than living apart.

26. Poogan's Porch, 72 Queen Street

A longtime favorite restaurant, Poogan's Porch, is reportedly the most gently haunted. Some say the little dog for which the restaurant was named shows up to greet guests. But the most reliable and repeated vision has been an elderly woman, dressed in black, her silver-white hair pulled into a bun leaving a soft halo around her face.

Visitors at the Mills House Hotel next door have, over the years, reported looking out their windows to see a woman waving at them from the second floor of the old house. She's been seen late at night, causing some hotel patrons to report in a panic that a woman was locked in the restaurant after hours.

Other sightings have been inside the restaurant itself. Some people have been spooked by the creaks and rattles

Poogan's Porch. Does a lonely spinster wave at passersby, hoping someone will come in to visit? *Courtesy of Tyler LaCross.*

and clanging pots one might expect in an old house that's been converted into a restaurant. That may not be surprising. After all, buildings settle, the wind does funny things and metal pots and pans can create noise in a restaurant.

Not so easy to explain, though, is the woman who sometimes strolls through the restaurant, coming face to face with a guest or a worker. The description is always the same: an old-fashioned, long black dress. The unexpected cold. The remarkable likeness to Zoe Saint Armand, who with her sister rented part of the house beginning in the 1930s.

Neither sister ever married, and both taught at the Crafts School, down Queen Street at Legare. Miss Zoe's students remember her as a strict task-master, demanding of them their best. Throughout her life, she was eccentric, keeping much to herself.

Miss Zoe's sister, Elizabeth, died in 1945. After her sister's death, Miss Zoe sometimes waved from the window to those passing on the sidewalk, inviting them in. She lived very much alone after her sister and her cat died, until she was taken to the Saint Francis Hospital nursing facility. She died there in 1954.

Is she still inviting people in for a visit? Don't you have a few minutes to spare to brighten a lady's day?

This is the end of the walking tour. Continue north on Meeting Street to return to the Market Street area.

PART II

CHARLESTON'S PAST
The Intriguing Bits

"THE STORMY PETREL"
Author's Note

No one has summarized South Carolina better than Walter Edgar in the preface to his *South Carolina: A History*:

> *During the 1920s two black expatriate South Carolinians, Benjamin Brawley and Kelly Miller, expressed the view that in the history of the United States few states were as important as theirs. Brawley wrote, "The little triangle on the map known as South Carolina represents a portion of the country whose influence has been incalculable." That influence, as Miller would note, could be good or bad: "South Carolina is the stormy petrel of the Union. She arouses the nation's wrath and rides upon the storm. There is not a dull period in her history."*

Throughout its long history, Charleston has maintained its eccentricities and pride, its schizophrenia and its

charm. As my grandfather Truman Pickens was fond of saying, "Folks don't change, they only get more so." The same can be said of Charleston, perhaps not surprising in a city that has survived as long as this one, that has faced the many challenges that have come against her and has still thrived.

Admittedly, in this short history, I have sought to capture the mysterious, the criminal and the unusual. Fortunately, Charleston's dramatic past does not require embellishment. Ghost stories, crime cases, wars, storms and pestilence tell us about a place and about the people who have called it home far better than dry recitations of dates and names can ever do.

Enjoy the stories and, if you are fortunate enough to visit the holy, haunted city of Charleston, enjoy the walking tour. Please respect the privacy of all—both living and dead—who call this home. Get to know the city as it really was and is—and gather as many of its stories as you can. The stories keep it alive.

THE KING'S FAVOR

After learning of Charleston's checkered, colorful, sometimes schizophrenic past, it should surprise no one to learn that "Charles Towne," South Carolina's earliest permanent settlement, was named for none other than the hard partying "Merry Monarch" himself, Charles II. As he enjoyed his Parisian exile while Cromwell controlled England, King Charles's sexual exploits became legend.

When Charles returned to England and ascended the throne, he brought his hearty partying ways with him. Charles believed in rewarding his friends and, in 1662, to reward eight of his friends, he "re-gifted" property originally given to others. The immense land grant stretched from what became the North Carolina–Virginia border to northern Florida—and ran the breadth of the continent from the Atlantic to the Pacific Oceans, through what became the Southern and Southwestern states to California and northern Mexico. A grand gift indeed.

The eight friends became known as Lords Proprietor, charged with establishing a colony that would be led by a defined aristocratic hierarchy. Their names are immortalized in the Carolinas today, as rivers, counties and towns: Clarendon, Monck, Albemarle, Berkeley, Carteret, Colleton, Cooper and Craven.

King Charles II apparently understood the value of having friends who shared his interests. Lord Anthony Ashley Cooper, one of the eight Lords Proprietor, was also known as "the greatest whoremaster in England" and recognized as a man who "loves fumbling with a Wench, with all his heart." He became chief among the Lords Proprietor.

For several years, England was distracted with a war, the bubonic plague and the Great London Fire, and the Proprietors couldn't convince the king to free up any funds for the settlement, development and defense of their grand gift. Eventually though, the Proprietors and settlers worked out a commercial plan to establish an English feudal system of plantations that could supply European markets with sought-after goods.

Lord Ashley Cooper is now memorialized in the naming of the two rivers that form the boundaries of historic Charleston—where, as some Charlestonians humbly opine, the Ashley and Cooper Rivers come together to form the Atlantic Ocean. The feudal system of nobility the Lords Proprietor originally envisioned

South Battery Street scene. *Courtesy of Tyler LaCross.*

was never formally established, and the city's name was changed when hostilities heated up between England and the American colonies. Charles Towne became Charleston so it wouldn't sound so much like a tribute to the monarch, but Charleston retained much of its heritage—both a sense of entitled supremacy and a shadowy debauchery swirled in an interesting mix.

All was not hard partying and profit seeking. On a progressive note, Lord Ashley Cooper enlisted a young John

Locke to write the Fundamental Constitution of Carolinas, an enlightened document that created a government that protected religious freedom and focused on the public good. This openness to diverse religious beliefs proved a strong draw to settlers in the early years of the colony. The first settlement in 1670 had a number of immigrants from Barbados who had already experienced—and survived— colonial life. Also among the early settlers were French Huguenots escaping Catholic persecution. Interestingly, among the provisions that these 148 religious freedom seekers brought were prodigious amounts of liquor; they insisted that the water didn't taste good unless mixed with spirits. Many insist that is still true today.

Charleston and the surrounding area had been investigated by Spanish explorers as early as 1521; both the English and the French tried settlements eight years before Charles Towne, but one group was driven in desperation to mutiny, murder and cannibalism as it abandoned its camp and returned to France. No successful settlement was established until 1670.

The English did send one important tourist into the wilderness. In 1674, Dr. Henry Woodward began traveling through the Backcountry, living among the Cherokee for many years, learning their language, what crops they grew and how they lived on the land. He served as a valuable liaison and translator for the colonists who followed—and, thanks to his writings, for historians to this day.

Both the Barbadians and the Huguenots were known as industrious and skilled workers, and they set about testing which crops, such as cotton, indigo and sugar brought over from Barbados, would grow best in the swampy, humid, bug-infested environs of the new colony. Along with these test crops, they also brought with them slaves and the long-established slave code from the Barbadian plantations.

The Huguenots were soon joined by English settlers. According to the WPA history of South Carolina, the early settlers included Quakers, Covenanters, Congregationalists, Baptists, German and Swiss Lutherans, Scots-Irish Presbyterians, Jews and a few Roman Catholics.

Even in religious matters, Charleston maintained its double-sided nature. The British General Cornwallis, trying to subdue South Carolina during the Revolutionary War, allegedly said "he feared the prayers of the young Baptist minister, Richard Furman, more than the armies of Sumter and Marion." (For more on Reverend Furman, see tour stop #24 and the tale of Lavinia Fisher.) However, shortly after the war, Bishop Francis Asbury, the American Methodist leader, wrote, "I now leave Charleston, the seat of Satan, dissipation and folly."

THREATS ON ALL SIDES

In the early days of the settlement, the colonists faced terrifying challenges, both from man and nature. After unsuccessful attempts at settling Carolina, the Spaniards moved on to settle in Florida and the French left for the Mississippi delta. Unwilling to relinquish what they'd first sought, however, the Spaniards and the French continued for many years to pose a threat to the Carolina settlers.

The threat of invasion was not the only threat the settlers faced, both by land and by sea. From the wilderness surrounding Charles Towne, the settlers faced the Native Americans' growing resentment of European incursions; from the sea, they faced the waterborne threat of pirates plying the Caribbean trade routes and coastal ports. The settlers had plenty to worry about.

The 1715 Yamasee uprising forced the colonists to fight back fifteen thousand angry Native American warriors. Long after the bloody battles stayed in their collective memory, the citizens continued to fear Indian

uprising, particularly during the Revolutionary War when they believed the British were inciting the Indians to attack.

For the most part, they maintained civil and congenial relations with the Indians, though it sometimes required delicate negotiations between warring tribes. In 1744, the colony's governor in Charles Town was called upon to intervene in what could have become another bloody Indian war. Following the earlier Yamasee War, the former Pedee and Cape Fear tribes had broken away from the Sioux to form separate bands. Around the same time, the remainder of the Notchee tribe (a common spelling of Natchez) had migrated from Louisiana after they'd been defeated by the French and Choctaw. Those Notchee who escaped being sold into slavery settled among the Creek and Cherokee tribes, with some making their home in Four Hole Swamp not far from Charles Town.

In 1744, some Pedee reported to the governor that seven Catawba, a tribe based south of what is now Charlotte, North Carolina, had been killed in a barroom brawl by two Notchee. The Pedee feared reprisals or all-out war from the powerful Catawba. Knowing that wouldn't be good for anyone, Governor Glen asked the Catawba to give him a chance to work things out. He then convinced the Notchee to punish the two Notchee tribe members responsible, in order to appease the Catawba tribe.

When the Notchee surrendered the severed heads of two men, no one doubted the accuracy of the identification because of the tattoos. The Notchee had a rigid class structure, with Suns, Nobles, Honored People and "Stickards" (untouchables) all identified by distinctive tattoos. The heads, with brains removed by a surgeon, were stored in casks of liquor for transport to the Catawba, who were satisfied and did not seek further vengeance.

In 1718, not long after the resolution of the Yamasee uprising, the settlers decided to face down the "pirate scourge," the threat that came from the sea. The pirates had begun to take too great a toll on the shipping of goods in and out of the port city. As a result, the pirate hunters set to work. Blackbeard was killed in a fiery battle in his happy hiding grounds on the coast of North Carolina; Stede Bonnet, a Charleston native with an aristocratic background (see tour stop #15), and forty-eight other pirates were captured, tried and hanged in Charleston in November and December 1718.

Even though the citizenry believed demons and threats had been vanquished and peace could reign, nature continued to throw her best challenges at Charleston.

The coastal climate is not an easy one, and in the early years, no one knew the cause of mosquito-borne diseases and those exacerbated by close quarter living. They only knew the results. Gravestones around the city's churches stand in testament to whole families decimated by yellow

Headstones in St. Philip's Churchyard. *Courtesy of Cathy Pickens.*

fever, malaria, whooping cough, smallpox, typhoid and malaria. Inhabitants knew spring, summer and fall were the deadliest seasons: "in the spring a paradise, in the summer a hell and in the autumn a hospital."

Pestilence wasn't the only fear in a city built with European close construction. The creation of the nation's first fire insurance association in 1735 could do nothing to halt the fire that burned half the city in 1740. Fear of fire remains ever present.

NATURE'S WRATH
Storms Past and Present

As if enemies, fire and pestilence failed to offer enough challenge, Mother Nature has more than once tested Charleston's resolve. The first major storm to batter the settlers came ashore on September 4, 1686. No scientific methods existed to measure its force, and waiting out the howling winds must have been a harrowing experience; the settlers would have had in mind the Native Americans' stories of storms so severe the water reached the tops of the trees. After the winds subsided and the settlers emerged, they found corn crops beaten flat and so many trees toppled that it was almost impossible to get around on horseback.

This first storm did, however, prove to be both a curse and a blessing, for it blew away one bit of worry. The settlers didn't know it at first, but a contingent of Spaniards intent on invading the settlement were approaching when the storm came ashore. The fierce wind and waves sent them packing back to Florida and saved the fledgling settlement from attack.

In addition to many smaller storms over the years, a major hurricane hit in September 1752, making a direct hit on Charleston Harbor and pushing ashore a ten-foot tidal wave. The wave left only one ship in the harbor, carrying all the rest ashore. A little more than two weeks later, while they were trying to salvage what was left of the rice crop and repair the damaged roads, bridges and buildings, a second hurricane brushed its outer skirts against Charleston.

Added to the challenges of recovering from the Civil War, the military occupation and an agricultural recession, two hurricanes hit the city in August 1885. The worst of the storms hit with 125-mile-per-hour winds and a high tidal surge; twenty-one people died, and 90 percent of the homes were damaged.

Just one year later, on August 31, 1886, the city was devastated by a major earthquake (discussed later).

Severe storms are not all distant history. For many South Carolinians, September 21, 1989, is not a date they'll soon forget. A category 5 hurricane approached the city after wreaking havoc across the Caribbean. Downgraded to a category 4, the once-in-a-hundred-year-size hurricane hit Charleston near midnight with 135 mile-per-hour winds, pushing a storm surge up to twenty feet. In South Carolina, 63,000 people were left homeless. The storm registered the lowest land barometric pressure ever recorded in the state.

Even harder hit was McClellanville, a village just north of Charleston that hosted the beach homes of some of Charleston's elite and served as mooring for a small shrimping fleet. The story of those who took refuge in the storm-flooded Lincoln High School is the stuff of nightmares for all who hear it, but it was Charleston proper that attracted national attention.

About ten o'clock at night, a man phoned a talk radio show in Charlotte, North Carolina, about 150 miles inland from Charleston. He said he'd left his house to walk near Charleston's Colonial Lake, watching the palmetto trees whip in the wind and electrical transformers blow all over the city. "You're the only radio station we have left," he said. "All the rest are down. I don't know if I'll make it, but I've lived a long life. If you could only see this…"

As dawn broke, the first news reports about Charleston announced that the historic city had been destroyed. The city hall, which was serving as the command post for all emergency rescue teams, lost its roof early in the storm, forcing the rescuers to find shelter. Houses along the Battery were flooded with six feet of muddy gray water carried by wind and extremely high tides.

The city was bowed but not beaten. Buildings that had weathered hurricane, fire and earthquake for more than two hundred years proved stalwart in the face of Hugo. Some stores still display photos of the damage; all who were in the area have their Hugo stories, and they'll share

with little prompting. However, if you haven't seen the pictures or heard the stories, just looking around the city makes the destruction difficult to imagine. It's amazing what fighting spirit and paint will do.

THE CRUEL INSTITUTION

Not all of Charleston's pain and trouble was wrought by nature or by enemies. Some it created for itself. Slavery, an institutionalized though not universally accepted part of pre–Revolutionary War life in the British Crown colonies, remained a blight on both the reality and the perception of the South.

No place better exemplifies how that institution affected both the owners and the owned than does Charleston, which by the early 1700s hosted the colonies' largest slave trade. Charleston was the scene of the first shot fired in the Civil War, as well as more recent battles over how to acknowledge history without offending those harmed in that past. Such history and strife keeps the wounds fresh.

The first slaves imported into Charles Towne came with their owners from Barbados and worked primarily as house servants. They lived and interacted closely with their owners because, in Barbados, slaves typically were treated as members of the family. This mode of interaction

characterized the early years of the colony. However, the South, because of its rich natural resources, began to export lumber, pine tar and turpentine for shipbuilding, then moved to crops in demand in England, such as tobacco, indigo (reintroduced to Carolina cultivation by a female planter, Eliza Lucas Pinckney), rice and eventually cotton.

The work required to carve rice plantations out of the cypress swamps around Charleston was backbreaking, disease-ridden work. By the time rice and indigo became the most popular—and extremely lucrative—crops, the landowners had accumulated enough wealth that they could separate themselves from the hard physical labor.

The slaves brought from Madagascar arrived with their centuries-old knowledge of rice growing—knowledge most of the plantation owners lacked. Rice production was not automated and required hands-on attention, accounting for a significant portion of the large slaveholdings immediately before the Civil War. For most of this production—and the wealth associated with it—Charleston was the center.

In history, all ethnicities have been and have held slaves. Long before the Carolina colony was settled, a slave class had developed in certain sections of Africa and was the source of the initial slaves who arrived in Charles Towne. Eventually though, the slave traders needed even more slaves and turned to inciting civil unrest among the African tribes.

Trade from Charles Towne took a triangular route. Indigo, rice and tobacco picked up at port were shipped to England and traded for rum, textiles and guns. These items were traded in Africa for slaves, who were then carried to the West Indies, where they worked on the sugar plantations or were readied for trade to the colonies.

Slave ship conditions from Africa were horrendous. Some of those trafficked, upon realizing their fate, decided to write their own history. Some starved themselves to death. Others jumped ship and drowned; in one sad tale, on a Georgia Sea Island, newly arrived slaves bound together in their chains walked into the water and drowned themselves as soon as they realized their fate.

The Africans did have some resistance to diseases, such as malaria and yellow fever, which decimated the Europeans in the subtropical South. However, a trip back into the swamps outside Charleston on a July or August day will quickly illustrate how brutal and difficult the work must have been for those who dug the canals to flood the rice fields. (For a side trip, visit Santee Canal Park in Moncks Corner. Canoe up one of the old canals dug by hand by slaves. The wildlife is beautiful; the heat, humidity and bugs in deep summer are unbearable; the appreciation of the toil of those brought here against their will becomes humbling and sadly real.)

Not only did they bring with them the technique and ability to cultivate the crops that made Carolina a valuable trading partner with England, but the Africans also brought skills in other domestic arts, such as basket making, cooking and crafts. Slaves and their descendants created much of the artisan work, such as the wrought-iron gates and woodwork details that decorated the homes in Charleston.

By 1708, the black population slightly outnumbered the white population in Carolina. Statistics for the entire state can be misleading because blacks were a small proportion in the Upstate, while in some Lowcountry parishes the percentage of blacks approached 80 percent. Blacks increasingly outnumbered whites, representing 60 percent of the colony's total population on the eve of the American Revolution.

PLAT-EYES AND BOO-HAGS

Another legacy brought by the Africans traveling by way of the Caribbean Islands is Gullah, a unique mixed oral language perhaps borne of necessity on the slave ships when members of different tribes developed a common tongue to communicate on the difficult journey. Gullah language started by mixing African dialects with English, and later with Spanish and French. Today, an overheard conversation around Charleston can unexpectedly bring visitors into contact with a language they've never heard before.

The slaves also brought, as part of their African and Caribbean culture, folk medicine known locally as root or root medicine, similar to Louisiana's voodoo. The traditions and superstitions that grew from this mix of folk and religious beliefs still color life in the Lowcountry, where plat-eyes still roam the swamps and back roads outside Charleston.

Plat-eyes are shape-shifters that assume the form of a cat, dog, owl or other familiar wild or domestic animal,

but they can also appear as a human apparition. Plat-eyes seem to like dark woods under full moons, particularly near graveyards. Stories often tell of travelers spotting first a small animal, usually ghostly white or with glowing eyes, trailing them in the woods, followed by a larger animal, then a larger one. Plat-eyes can also appear in a victim's house and can be conjured by a root doctor to torment a victim with remorse or guilt over a deed done to another.

The best way to avoid plat-eyes in the woods is to be home by dark. When a plat-eye appears in a victim's life, though, it can be difficult to shed it. Plat-eyes do have a notable weakness for whiskey and can sometimes be distracted with a good stiff drink.

The tradition of painting window frames, porch floors, roofs and doorways a pale, watery blue grows from the Sea Island root belief that spirits (or haints) can't cross water. Therefore, the color of water offers protection to those inside. The first source of the blue color may have been the byproducts of indigo production in the 1700s.

One threat to those who make it safely home at night, inside their houses with windows open to admit the cooling breezes, was the dreaded boo-hag. Boo-hags are witches feared because they can slip through the smallest unprotected opening—even a keyhole. Because some boo-hags lack their own skin, they must go in search of someone else's. They climb atop their sleeping victims and suck their breath. The next morning, after having been

Door knocker. *Courtesy of Tyler LaCross.*

"ridden by the hag" all night, the victim awakes exhausted and faint. The boo-hag usually spares the victim so it can return and avail itself later. Sometimes, though, the boo-hag rides the victim to death.

Many of us have awakened in the morning feeling more drained and tired after our night's sleep than before we went to bed. In the Lowcountry, folks will warn you that you've been ridden by the boo-hag. To ward off a boo-hag once it has claimed you as its victim, you must rid your house of all places where it can perch during the day, such as bedposts or lamps. Some have tried to grab hold of a boo-hag because, once caught, she won't return. You'll know if you've caught one: boo-hags reportedly feel and smell like raw meat.

Boo-hags don't like salt (something to do with being raw meat, probably), and they can also be distracted with things that need to be counted, like the holes in a strainer. Hanging a strainer or colander on the doorknob sometimes keeps the creature occupied until daybreak, when she has to return to her skin (if she has one) or be banished forever. However, sometimes a boo-hag becomes so attached to a victim that the victim must go in search of the heavy charm of a root doctor or risk perishing.

CRIME AND PUNISHMENT

Crime statistics were not gathered until 1887, when about one hundred murders occurred in South Carolina—a great number, twice what occurred that year in all the New England states combined. Most of the murders were committed by whites, though blacks began to follow whites' bad habits as they gained more ready access to guns. As today, whites killed whites and blacks killed blacks, with the occasional crossover killing.

Color did have some influence over where a given murder occurred, according to historian John Hammond Moore. To stay safe, whites would have been wise to avoid stores and law offices, where more white murders occurred; blacks should have stayed away from dances, card games and church services.

As today, pundits attempted to explain the violence, blaming it on everything from slavery to a gun culture to a nature peculiarly sensitive to slight or insult. Of course, as is true today, liquor played a large role in most of the killings.

In 1880, South Carolina outlawed concealed weapons, including "pistol, dirk, dagger, slung shot, metal knuckles, razors" and the like. It did little good. When guns or sophisticated weapons were unavailable, murder was done with "knives, axes, hoes, bottles, planks, pine knots, or fence rails," according to Moore.

Unlike in the large Northeastern cities, more South Carolina murders happened in the country than in the towns, likely because the killings could take place out of sight of witnesses and law officers. Lynching was also a largely rural occurrence, probably for the same reason.

On the other hand, duels were often a city affair. Dueling hung on in the South into the late 1800s, and Charleston was a popular place to host such battles of honor. (See tour stops #10 and #16.)

Charleston also attracted its share of "white-collar" criminals—scam artists, counterfeiters and forgers. In the late 1800s, Dick Walters hit upon a "colorful" get-rich-quick scheme. He dyed himself brown and got a friend to sell him as a mulatto slave; he then would engineer his escape, wash off the dye and split the money with his accomplice. Unfortunately for Dick, after several successful escapades, he found he couldn't wash the dye off completely, so in his daily comings and goings, he had to repeatedly prove that he was not a black man.

"Organized" crime in Charleston may have hit its heyday during Prohibition and into the 1930s. While

Charleston gangsters didn't attract national attention, they nonetheless had lucrative gambling, liquor and prostitution businesses to protect and weren't afraid of violence. Charleston during this period reportedly had a per capita homicide rate two to four times that of Chicago and New York. (See tour stops #1 and #2.)

Of course, Charleston had imported much from England, including its legal system. As in England, the law during the early 1700s manifested a rugged, unyielding "eye for an eye" vengeance. Punishments for thievery, for example, could range from a public branding or whipping, cutting off an ear or a hand or even death, if the theft involved something valuable like a horse. Death was uniformly the penalty for murder as well as a host of other crimes; hanging was typical, though some murderers were publicly burned. In one tragic case, two female slaves accused of poisoning a white child were burned to death.

Executions were swift—construction typically began on the gallows as soon as the verdict was handed down by the judge, and the execution followed in days or weeks, not months or years. At one point, executions behind the present-day county courthouse were held at least once a month.

As in England and the rest of the colonies, public executions were events that attracted picnickers and day-trippers. In a time that lacked daytime talk shows

and mass-produced self-improvement books, the spectacle was intended to benefit the public. Usually the condemned criminal spoke from the gallows, giving a life history outlining how bad choices and succumbing to evil influences had led him to this sorry state; he would finish with a confession of his sins and seek forgiveness and hope for redemption from both God and his fellow men before being "launched into eternity." Pamphlets summarizing these cautionary tales were often printed and sold immediately after the execution.

As in England at the time, the list of death penalty crimes in Carolina was significantly longer than it is today. Courts could also exact less severe forms of retribution for bastardy, Sabbath breaking, public drunkenness and cursing. Despite its harsh laws, by 1720, Charles Town was a wide-open party town (except for the Methodists, who preached a hard line against drinking). By 1770, the city boasted a tavern for every five male residents.

Except for the Methodists, the ministers of the city were known to enjoy their drink. A rum tax even helped to pay for the construction of St. Philip's Church. During the nationwide revival known as the Great Awakening, the Methodist Reverend George Whitefield attracted huge audiences with zealous, impassioned preaching and an emotional response to faith not unfamiliar to Southern Protestant church-goers today. However, that sort of emotional zeal was not in keeping with the

more somber, dour conduct of most of the colonial-era parishioners and pastors.

St. Philip's Church refused to allow him to preach there, but Dr. Whitefield often borrowed the Congregational church or the French Huguenot church pulpits for his hell-fire-and-brimstone sermons. His preaching attracted censure as well as listeners. According to Charleston writer Mark Jones, in the heat of one sermon, likely based on the Isaiah 3 warning that "the Lord will take away the finery" and give "instead of beauty, shame," he pointed to one wealthy widow in the congregation as an example of how not to dress. Following the sermon, Mrs. Anne Le Brasseur reportedly went home, took a pistol and shot herself over the public embarrassment.

THE FIRST CIVIL WAR

By the time of the American Revolution, the economic and cultural divisions between the Upstate and the Lowcountry were solidly ensconced. Much of the division grew from the difference in economic base: by the mid-1700s, Charleston was the fourth largest of the colony's cities (behind Boston, New York and Philadelphia) and, thanks to the lucrative rice and indigo plantations, it was decidedly the richest. By 1775, the colony was predominantly black, with the Charleston area population almost two to one. The Upstate, however, was mostly whites farming modest holdings and nurturing the seeds of an industrial base and a disdain for the pampered, privileged Charlestonians.

The Revolutionary War was South Carolina's first civil war, fueled in part by the differences that had developed within the state. Charleston in particular had strong trading ties with England, so Tory sentiment was strong. Nonetheless, economic threats even Charleston couldn't ignore ignited passions, and in 1776 the Patriots repelled

the first attempt to capture the city and kept the British at bay for almost four years.

Toward the end of 1775, the British army wasn't faring well in Boston, where it faced General George Washington. So it turned its attentions southward, planning to build on the strong Tory sympathies and tie up the South for Britain. General Henry Clinton sailed to Cape Fear, on the North Carolina coast, to meet with Admiral Peter Parker, Major General Charles Cornwallis and "hordes of Loyalists." The fleet was six weeks late, and the hordes never showed up.

That was the first bad omen. However, with superior fighting men, equipment and experience, the Brits thought it shouldn't take long to mop up the Southern campaign, solidify control and still return to fight in Boston after the spring thaw.

The British didn't expect, in the short time available, that they could reasonably expect to capture Charleston, but they could control the shipping channel from a vantage point on nearby Sullivan's Island, west of Charleston. Or so they thought. They quickly ran into unpredictable channel currents and sink holes, rugged island wilderness, determined men, the mellow but experienced Patriot Colonel William Moultrie and a partially finished fort made of a spongy, fibrous, subtropical tree.

Continental army regiments began arriving in Charleston in June, supplementing the South Carolina

militia with 6,500 men. At this time, the South Carolina troops were not officially part of the Continental army, but joined together under General Charles Lee, an experienced English military man who had signed on to fight with the Americans.

General Lee argued that the fort—or "slaughter pen," as he called it—on Sullivan's Island should be abandoned. When South Carolina's governor told him that wasn't an option, Lee tried to establish an escape route (a floating bridge made of planks and barrels). However, Colonel Moultrie never thought he would have to abandon the fort, so he never got around to building Lee's bridge, despite Lee's constant reminders to get on with the job.

With a fifty-ship armada, the British thought it would be easy to take a fort that was only partially finished, with walls on two sides and its petticoats showing, so to speak, on the other side. The British had wisely not planned only one front of attack, but, in implementing their rear move, they faced a twin obstacle at the remote end of the island: the impenetrable subtropical undergrowth and the sharp-shooting of the 780 men sent to defend the island wilderness. These were, after all, men who often had to shoot game for supper. They knew how to use a long gun and how to hide and wait patiently.

With their rear assault plan forestalled, the British proceeded with the 270 guns on their warships to bombard

the fort, with its four hundred men and its paltry 25 guns. To their surprise, despite heavy bombardment, the half-finished fort sustained little or no damage. The Patriots had, under Moultrie's direction, uprooted sabal palmetto trees, stacked them on top of each other to form two rows and then filled the gap with sand to form sixteen-foot-thick walls. The cannonballs either bounced off the resilient palmetto logs or were absorbed into the wall, and the fort remained intact despite intense shelling.

The wooden vessels of the British fleet did not fare so well, however. Under the slow and deliberate fire from the fort's twenty-five guns, the vessels sustained splintering damage.

The British decided to sail three ships past the island to a point where they could easily train their guns on the open sides of the fort. This was the line of attack most feared by General Lee, the fear that had prompted him to order the escape bridge that Moultrie never built.

The Brits had a good plan, right up to the time the ships ran aground on the shoals off the island and presented perfect targets for broadside fire from the fort. The Patriots, worried about running out of ammunition, took their time and made every shot count. As a result, the Patriots were hit with seven times more shots than they fired, but they killed almost six times as many as the British did. At the end of the day, the British had two hundred dead or wounded; the Patriots lost thirty-seven.

Palmetto trees helped
thwart the first British
attack on Charleston.
Courtesy of Tyler LaCross.

A year earlier, Colonel Moultrie had been asked to
design a flag under which South Carolina's troops would
fight. He used the indigo blue of their uniforms and
placed the crescent worn on their hats in the upper corner.
At one point in the battle—one of those points from which
legend is made—the indigo blue battle flag was shot off
the rampart by the British. Sergeant William Jasper flung
himself over the wall and, despite heavy fire, rescued the
flag. He attached it to a sponge staff, used in preparing the

guns for firing, and set it again upon the rampart. A statue at Charleston's White Point Gardens (see tour stop #15) memorializes Jasper's cry to Colonel Moultrie: "Don't let us fight without a flag."

At the end of the long, hot June day, the British fleet sailed away. The half-finished, "spungy" log fort and the constancy of the men inside had delivered for the Americans one of their first major victories.

A hundred years later, at the time of Secession, the palmetto tree commemorating one of the state's most dramatic battles was added to create a new flag for the nation state. It remains South Carolina's symbol.

The little log fort is now the site of Fort Moultrie on Sullivan's Island, a much more ambitious construction than that undertaken by Colonel Moultrie. The fort is open for tours and is also the burial site of the young Seminole Chief Osceola, who rejected a treaty that would force his tribe to move from its Florida swamp. He was imprisoned in the fort in 1837, where he died from malaria.

As an interesting side note, the fort hosted two unlikely guests during its active service days. William Tecumseh Sherman spent two tours of duty there in the 1840s; some speculate that he fell in love with Charleston—or maybe fell in love with someone *in* Charleston—during that time and therefore did not add Charleston to the list of cities destroyed in his March to the Sea, though he surely thought this hotbed of insurrection deserved punishment.

An earlier inhabitant also left a legacy for Charleston. Edgar Allan Poe began service at the U.S. Army fort in 1827 and, years later, immortalized Sullivan's Island as the setting for his treasure-hunt mystery, *The Gold Bug.*

By late 1780, the British brass had learned a lot about fighting a new kind of war. When Sir Henry Clinton returned to capture Charleston, he didn't sail blindly into the fortified harbor. He avoided the remnants of the ships the Patriots had sunk in an attempt to block access to the harbor and instead sailed to Johns Island, where he snuck troops in through the swamps and set up fortifications to shell the city.

After a two-month siege, Charleston's military leader General Lincoln accepted the terms offered for surrender. The Patriots, including those who had taken up arms, would be paroled and could return to their homes. The British—probably chafed at spending all that time in cold swamp muck—hit Charleston with one last and mighty fireworks display, which was enthusiastically returned by the Patriots who still held Charleston. General William Moultrie found it "a glorious sight to see the shells like meteors crossing each other, and bursting into the air. It appeared as if the stars were tumbling down."

The city surrendered on May 12, 1780, with adult males agreeing not to take up arms against the British. The occupation might have gone as planned except that, two months later, the British commander ordered that all

former Patriots must swear allegiance to the Crown and must, if called upon, take up arms to defend it. Being called to fight their neighbors had not been part of the deal, and neither had the plundering or confiscation of Patriot estates.

Once they had gained control of Charleston, the Brits chose to use strong-arm tactics to set an example and bring the rest of the state under control. Burning Thomas Sumter's house near Nelson's Ferry was not a smart move. In the movie *The Patriot*, this incident became part of a Hollywoodized composite story of the three most famous leaders of the South Carolina resistance: Francis Marion, the Swamp Fox, who operated in the heavily wooded swamps north of Charleston; Thomas Sumter in the mid-state; and Andrew Pickens in the Upstate.

In 1781, in an attempt to bring the locals under control, the British imprisoned and executed Isaac Hayne as a traitor. (See tour stop #14.) Initially, it had the desired effect of persuading other Patriots of the folly of again taking up arms against the occupiers. However, as the ill-conceived and often brutal campaign to subdue the countryside spread into the Backcountry, it did little but fan the Patriot flames.

Apparently South Carolina failed to hire an effective public relations firm following the Revolutionary War, because the importance the Southern field played is little known, compared to the well-known tales from New

England. However, more Revolutionary War battles were fought in South Carolina than in any other state, and a greater percentage of the population actively fought.

Unfortunately, many of the South Carolina soldiers were fighting each other because the state was deeply divided in its loyalties. The battles were bloody, with heavy loss of life, and most of the battles were fought between local Patriots and Tories. The Backcountry men, used to rugged lives and struggle, were formidable fighters. In one of the few battles against British Regulars, the Overmountain Men, as they were called—crack shots with their squirrel rifles— came from the southern Appalachians to join the Carolina men at Kings Mountain. Angry over British Colonel Banastre Tarleton's massacre of 150 men after they had surrendered in an Upstate battle, the Patriots soundly defeated Major Patrick Ferguson at Kings Mountain, and quickly followed with another British defeat at Cowpens. These British losses paved the way to the eventual rout of British forces in the Southern theatre.

Even after independence was won, South Carolinians could be counted on to show up whenever there was a fight. John C. Calhoun (whose towering monument stands in Marion Park on Calhoun Street between King and Meeting Streets) and three other South Carolina Congressmen were among the war hawks who advocated a declaration of war in 1812. In the 1847 Mexican-American war, the flag that flew over Santa Anna's citadel

in Mexico was the flag of the Palmetto Regiment; among approximately one thousand South Carolina men who left to fight, about five hundred didn't return home—three times the death toll of the U.S. Army as a whole.

When Southerners weren't helping the United States fight with other countries, they were agitating among themselves. At least as early as 1827, the Charleston-area planters were talking about Secession, as they were angry over tariffs that interfered with their trade with England. The economic animosity was further fueled by increasing insistence by some—though certainly not all—Southerners that the right to own slaves not only be preserved (despite the fact that the United States outlawed further importation in 1806), but that it be expanded to new territories.

THREATS REAL AND IMAGINED

In the Lowcountry in particular, whites lived as the minority race. A fearful recognition of that haunted the imaginations of many after the first and largest slave uprising, the 1739 Stono Rebellion, brought those fears frighteningly to life. A group of slaves broke into a store near the Stono River to steal supplies. They murdered the owners and left the decapitated heads displayed on the store's front steps.

Summoned by beating drums, the band gathered about one hundred slaves. They cut a murderous swath on their way toward St. Augustine, Florida, looting and burning homes. The militia went in pursuit. The brutality on both sides was shocking and, in the end, seventy-five whites and blacks were killed. Harsh measures enacted to quell any future uprising only served to deepen the tensions.

The next major uprising in Charleston came in 1822, led by a black freedman named Denmark Vesey. Vesey had bought his freedom with lottery winnings and had worked in Charleston as a carpenter for twenty years. Preaching

the Bible's Book of Exodus from the AME pulpit and using the offices of a powerful Gullah root doctor called Gullah Jack, Vesey built his insurrection. The plot was uncovered because of a tipster, and seventy-nine blacks were tried; thirty-five were executed and the rest were sent out of the state to prevent any future collaboration.

Even when they faced no large-scale plots, whites, decidedly in the minority, feared their slaves might turn on them. Beginning in the early 1700s, the historical and court records are dotted with references to slaves charged with poisoning a family member or setting a house on fire. In a time when organized fire protection and fire insurance or medical knowledge of diseases and food poisoning were scant or nonexistent, slaves may have often been the scapegoat for vagaries and maladies that could not otherwise be explained.

Southerners did not unanimously support slavery. Only 6 percent of the white population in the South owned slaves. Robert E. Lee called slavery "a moral and political evil," though he counted on Christian goodwill rather than political action to resolve the situation. Stonewall Jackson "wished to see the shackles struck from every slave." However, Charleston had richly benefited from both the slave trade and from slave labor, which continued to fuel divisions between the Upstate and the Lowcountry. Regardless of their stance on slavery, one thing South Carolinians—and Southerners in general—shared was an

intense resentment at being told what to do. In particular, they resented heavy-handed interference from the North.

Not only was the first military shot of the War Between the States fired in Charleston Harbor, at the Federal troops stationed in the harbor at Fort Sumter, but enlistment rates were also high. In Virginia, for example, 15,000 men hired substitutes to serve in their stead; in South Carolina, only 791 did. About 60,000 South Carolina men—roughly the full number of eligible fighting males—fought in the war.

South Carolina also lost a greater percentage of its male population in the war than any other state. Death tolls show between 18,600 and 21,000, so South Carolina lost over 30 percent of its men between the ages of eighteen and forty-five in the four years of fighting.

Perhaps no tale tells of their passion and dedication, even in the face of crushing odds, than the story of the little fish boat, the *H.L. Hunley*.

The Fish Boat

In 1864, Union forces had successfully blockaded Charleston Harbor. President Abraham Lincoln wanted to squeeze the life out of the South, and its principal port and the start of all the trouble was the focus of his aptly named Anaconda Plan.

The suffering within the city increased, both from lack of supplies and from almost constant shelling. Confederate General P.G.T. Beauregard was charged with breaking the Union blockade, but he feared the means at his disposal almost as much as he feared the results of a continued blockade and bombardment.

In 1863, H.L. Hunley and two other staunch Alabama Confederates invested Mr. Hunley's money to build the first fully submersible submarine, intended as a privateer and destined for the record books. An engineering wonder, it consisted of a thin, 40- by 4-foot torpedo-shaped tube to which was later added a 20-foot spar carrying ninety pounds of explosive; it housed eight men in its 4- by 3.5-foot cabin. The men sat hunched

Replica of the
H.L. Hunley.
The replica of
the Confederate
submarine
was built from
descriptions forty
years before the
ship resurfaced.
*Courtesy of Tyler
LaCross*.

on benches and powered the ship by hand cranking a center shaft.

In original designs and tests, the *Hunley* submerged and passed under the target ship while trailing a floating explosive mine on a rope. The mine would hit the side of the ship and detonate, after the *Hunley* had passed safely under the ship and powered away from the blast. In Charleston, the design was modified by borrowing a spar used on a torpedo boat to ram the explosive into the target ship, so the vessel didn't have to fully submerge.

With the hatches closed, the "fish boat" could fully submerge. One shortcoming of the design, though, was that submersion meant the men were left breathing and re-breathing only the air contained in the vessel. To conserve air, they also traveled with little or no light—at most, only a single candle. But the submarine presented a decided advantage for the naval front in the war, at a time when the Confederate fleet had suffered serious losses and when the blockade runners were almost out of luck.

The *Hunley* arrived by train in Charleston, and crews began training in spring of 1863. The early training missions failed horribly. Thanks to crew error, five men in the very first crew drowned when the vessel submerged with the hatches still open. The narrow confines meant that the water rushing in blocked the escape of most of the men.

The craft was raised, the bodies removed, the interior cleaned and training continued. Before long, another crew suffered a similar fate: eight men died, including the vessel's builder, H.L. Hunley, who had forgotten to close the seacock. As a result, the *Hunley* earned the nickname "murdering machine" and a "peripatetic coffin."

General Beauregard was on hand when the crew was recovered after the second tragic accident. He later wrote that it was "indescribably ghastly. The unfortunate men were contorted into all kinds of horrible attitudes...and the blackened faces of all presented the expressions of their despair and agony."

Beauregard felt the heavy mantle of responsibility for future crews. He made sure all were warned about the serious risk, but the volunteers who stepped forward far outnumbered those needed to mount the ambitious and much-needed campaign to break the blockade of Charleston Harbor.

Meanwhile, spies had leaked word to Union troops that the Confederates possessed an "infernal machine," some mysterious underwater weapon. Though they were on the lookout, the Union troops didn't discover the nature of the machine until it was too late.

Beginning in January 1863, the *Hunley* and her crew cranked through the winter harbor waters, surfacing occasionally from their six-foot depth to search for a target and wait for calm water. On February 17, they had both.

The *Housatonic* was a little over five miles south and east of Fort Sumter at the mouth of Charleston Harbor. The wooden sloop, one of the U.S. Navy's newest, was destined to become the first ship ever sunk by a submarine attack. A watchful sailor on deck spotted something in the water, but the alarm came too late to save the warship *Housatonic*.

The *Hunley* spar rammed the barbed explosive into the ship's planking, reversed direction and pulled a trigger rope to set off the black powder charge.

Everything went according to plan. The ship sank in mere minutes. However, because it was in shallow water, the crew was able to hang in the rigging until the rescue boats arrived. The Union lost only five sailors, but the *Hunley* did its job well. The damage to the *Housatonic* left it sitting in the harbor, unsalvageable. In later years, it took two separate explosions to clear the wreckage from the shipping lanes.

After the sinking, the mystery began. The *Hunley* disappeared. Evidence indicated that she had made it clear of the explosion because she signaled her success to Sullivan's Island with her blue lantern, but she never reached the signal fire built on the beach to guide her home.

In all, twenty-one volunteers died during training and the single mission of the *Hunley*.

Knowing who gets credit for discovering the vessel has been almost as great a puzzle as the 131-year-old mystery

of the sinking. Dr. E. Spence Lee, a South Carolina native and avid Carolina wreck hunter, spent years studying tidal charts, maps, war accounts and the harbor floor. In 1970, while diving for a fish trap, he spotted a ledge in the sand. He studied it and probed the sand, coming to believe he'd found the object of his years of search. Dr. Spence reported the discovery in 1970, and later donated his rights to the submarine to South Carolina. However, Clive Cussler, best-selling author of the novel *Raise the Titanic*, led and funded the continuing search that located the elusive ship in 1995.

Who really found it first is still debated, but eventually, in August 2000, swaddled in a steel-beamed, padded hoist, the *Hunley* was raised from the sea floor and moved to a facility at the former naval base, where researchers set to work trying to decode the maritime mystery.

Newspapers around the globe reported the first discoveries. The bodies of all eight crewmen were still at their posts. Also located were an engraved pocket watch, a comb and a twenty-dollar gold piece. The most poignant part of the mystery proved to be its humanity. These were real men, with real families and real dreams and fears, who had taken on a dangerous but ultimately ill-fated mission. They were given a full military funeral, 136 years after they'd left their families, with the longest funeral procession Charleston has ever witnessed.

The drive into the historic district on Meeting Street passes right by an almost accurate replica of the *Hunley* in front of The Charleston Museum (360 Meeting Street), built only from historic descriptions forty years before the real *Hunley* resurfaced.

The vessel is remarkably small, especially when considering the size of the crew and the conditions under which that crew went on its silent, single mission.

Charleston fell a year to the day after the *Hunley*'s mission. After the war, when South Carolina refused to ratify the Fourteenth Amendment to the U.S. Constitution, the state government was abolished by the Reconstruction Act and, along with all the other Southern states except Tennessee, the state was put under military rule. A commander was sent from up North to run the state: General Daniel Sickles.

THE MURDEROUS MILITARY GOVERNOR

After 1865, South Carolina discovered new levels of debasement as a conquered foe. Congress, flouting the plan presented by President Johnson to rejoin the South to the Union, responded to the Southern states' concerted refusal to reconstruct themselves by setting additional requirements for the South's readmission. These included ratification of the postwar amendments to the Constitution. When the Southern states refused to comport themselves appropriately, Congress divided the South into military districts over President Johnson's veto.

As a result, in March 1867, Major General Daniel Sickles took command of North and South Carolina, which composed one of the five military districts in the South. Sickles proceeded to exercise military authority, nullifying state laws and court decisions and even sentencing men to death for noncriminal offenses, even though the United States Supreme Court had declared trial by military commissioners unconstitutional.

Though he was not a favored visitor, South Carolina histories rarely mention Sickles's pre-Carolina past. In turn, most accounts of Daniel Sickles's life don't even mention his sojourn in South Carolina. Instead, they talk about his status as a Union general and his time as U.S. foreign minister to Spain—and his trial for murder in Washington, D.C., in 1859.

One account remembers Sickles as popular in diplomatic circles, with "ready wit and manly elegance." Another account talks of ambition and controversy. The facts about Sickles were well known and incontrovertible; the perceptions of him were varied and not altogether complimentary.

Sickles sacrificed a leg at the battle of Gettysburg, earning him the rank of general in the Union army. His physical handicap did not deter him from cutting a wide swath through the political landscape of the late 1800s. As one account summarized his career, he was "notorious as a political intriguer, dirty dealer, rogue, and ladies' man."

On his diplomatic assignments in Europe, he had taken with him his young, beautiful, dark-eyed wife, Teresa Bagioli Sickles, who had quickly charmed London and Washington society. Daniel Sickles then settled into the practice of law, his political connections along with his polished and beautiful wife attracting clients.

In one hard-fought victory in a libel case, Sickles defeated the U.S. attorney representing the District of Columbia: Philip Barton Key, son of Francis Scott Key, author of "The Star-Spangled Banner."

Philip Barton Key was a confirmed bachelor, described as six feet tall and craggy, powerful but not particularly handsome. He seemed to know the effect he had on women, young and old, influential and insignificant. As had everyone who was anyone in Washington and traveled in the right circles, Key met the beautiful Teresa Sickles.

Some accounts talk of Sickles's jealous hatred of Key because of his aristocratic upbringing, in contrast to Sickles's bootstrap journey. Others talk of Sickles's indifference to his wife; he left her alone at home while he wined and dined, flirted and intrigued his way through Washington society.

Whatever the truth, Key became a regular visitor at the Sickles's home, eventually entertaining Teresa some afternoons while her husband was absent. Sickles seemed pleased that Key was impressed by his wife, maybe because his ever-ambitious instinct told him Key could be valuable, if not as an ally, then as an opponent whose weaknesses were known.

At first, Teresa Sickles and Philip Key kept their relationship within the boundaries of proper social constraint. As Sickles directed more attention to building his career, though, Key directed his attentions to Sickles's

abandoned wife. Before long, the two were spending so much time together, alone, that tongues began to carry tales.

Finally, one day, the tales came home to Daniel Sickles in the form of an anonymous letter:

Washington, Feb. 24ᵗʰ, 1859

Hon. Daniel Sickles:

Dear Sir: With deep regret I inclose to your address these few lines, but an indispensable duty compels me to do so, seeing that you are greatly imposed upon.

There is a fellow, I may say, for he is not a gentleman, by any means, by the name of Philip Barton Key & I believe the district attorney who rents a house of a negro man by the name of Jno. A. Gray situated on 15ᵗʰ Street bt'w'n K and L Streets for no other purpose than to meet your wife Mrs Sickles, he hangs a string out of the window as a signal to her that he is in and leaves the door unfastened and she walks in and sir I do assure you

With these few lines I leave the rest to you to imagine.

Most Respfly
Your friend
R.P.G.

No one ever learned R.P.G.'s identity, but the letter gave enough details that Sickles could go in search of the house with the closed shutters. He learned that Key, well known as the district attorney, rented a house on the street populated mostly by poor renters, both whites and blacks.

Sickles then enlisted the aid of a man who had once served as his clerk to spy on the house to see if his wife was indeed its frequent visitor. The former clerk's questions to the neighbors eventually confirmed the suspicions—the veiled woman who regularly joined Key at the house wore dresses remarkably similar to those hanging in Teresa Sickles's wardrobe.

At trial, the testimony indicated that Teresa at first denied her guilt to her husband, but she eventually, in front of witnesses, signed a statement admitting her guilt. The protestations in her confession that it "was written by myself, without any inducement held out by Mr. Sickles of forgiveness or reward, and without any menace from him" convinced most who read it that Sickles had dictated it.

Teresa then disappeared, going to her father in New York for refuge but forced to leave her daughter Laura behind in Washington with her husband.

The next afternoon, after Sickles had confronted his wife and elicited her confession, Sickles caught up with Key on a Washington Street, pulled a gun from his overcoat pocket and shot him. He fired twice more as he fell to the ground. Key was unarmed.

Courtesy of Tyler LaCross.

The news that the district attorney had shot dead the unarmed New York congressman on a day-lit Washington street in front of witnesses spread quickly. The sensation grew beyond all sense and reason.

The oddest part of the story may be that Daniel Sickles became the hero. As his trial approached, public sentiment swelled in support. Teresa's sad and sordid confession fueled her husband's popularity after someone—probably Sickles's defense team—leaked it to the press.

His trial represented the first use of the insanity defense in a U.S. trial. His real defense didn't have to be openly stated. At a time when women were little more than property, it was considered just and proper to kill a man who "steals" that property.

The trial lasted almost three weeks. Despite the fact that Sickles repeatedly shot an unarmed man, the jury returned a verdict of not guilty. Sickles walked out of the courtroom a free man, a husband defending his wife, honor and home against an intruder.

Within months, Sickles was trying to defend himself to his once-adoring public for doing what many of them couldn't quite understand: he forgave his wife. Teresa returned to the couple's home, but it was far from a happy reconciliation. She was seldom seen in public again.

After the sensational murder trial, Sickles went on to distinguish himself as a Union army officer, then headed off to the Carolinas to set them straight after the war.

Unfortunately, Teresa Bagioli Sickles, the once vibrant toast of Washington political society, did not live to see her husband's military successes or his short stint as military governor of South Carolina. Within two years of the trial, Teresa was dead at the age of twenty-five, her young daughter Laura left to lead the unhappy life that is so often the legacy of children whose childhoods are swallowed up in the wealth, indulgence and tragedy of their parents' lives.

Sickles survived to be appointed ambassador to Spain by President Ulysses Grant. There, he met an intriguing European lady who became his wife. He lived to age ninety-three, never publicly mentioning his wife Teresa or his murder trial.

THE GROANING EARTH

Bombardment, siege, fire and pestilence had challenged Charleston's survival. Then, two decades after the Civil War, the earth itself turned enemy. Just before ten o'clock at night on August 31, 1886, the earth began to tremble, accompanied by a great roar. Reports all spoke of a loud groaning rumble, which arrested everyone's attention just before the tremors started.

The quake reportedly lasted slightly less than a minute, but aftershocks likely prompted the reports that it lasted eight minutes. The quake destroyed two thousand buildings and damaged thousands more. No accurate measurement system existed at the time, but estimates based on the documented damage are that the quake would have fallen between 6.6 and 8.0 on the Richter scale. Using another method that measures quakes by the area covered, the 1886 quake was huge, covering most of the Eastern United States. Of the 435 quakes in this region since the mid-1700s, over 300 were aftershocks from this quake that continued for thirty-five years.

To put this in perspective, the 1989 San Francisco quake (which hit less than a month after Hurricane Hugo hit Charleston) registered 6.9, lasted for only thirteen seconds, with several lesser aftershocks, and left twelve thousand people homeless.

That night, after only minutes of an eerie silence, another strong tremor started, also accompanied by a frightening roar. This shock was slightly less severe, but this one caused most of the deaths because people had rushed in fear or wandered stunned out of their homes. (See tour stop #13.) Buildings damaged by the initial rumble began to collapse into the street; some fifteen thousand chimneys toppled, creating a shower of bricks in the street. Many believe that, had the quake hit during the day, the death toll would have been much higher.

Given the confusion and the breakdown in communication, estimates of death and injury are sketchy. People were too busy taking care of the injured and finding shelter for the displaced to worry about accurate recordkeeping, but a reported 110 people died, from a population of 35,000.

Witnesses reported some unbelievable sights: seventy-foot-high geysers of sand. Broad Street rolling in ten-foot-high waves. Deep cracks along the Ashley River. Bent railroad tracks. The quake was felt as far away as Boston, Chicago and the Bahamas.

Earthquake bolts. After the devastating 1886 earthquake, rods were installed in an attempt to repair damaged buildings. *Courtesy of Tyler LaCross.*

Charleston sits on the Woodstock fault. The only two fault lines in the United States that present more risk of severe eruption are the San Andreas Fault (California) and the New Madrid Fault (Mississippi River basin). Charleston had experienced earthquakes before, in 1763, 1811, 1812, 1843 and 1857. Nothing could have prepared those who had been around in 1857 for what struck in 1886. Of the brick buildings, 90 percent were damaged. The front portico of Hibernian Hall collapsed into Meeting Street. The steeple on St. Michael's Church sank several inches, and severe cracks developed around the front.

Insurance was almost nonexistent for such damage, and government aid was unheard of. The railroad tracks and telegraph lines were damaged, so word of the extent of the damage and injury was slow to filter to the outside world. As had often been the case, Charlestonians had to rely on themselves to put their world back together.

Washington Park and other open areas around the city became campgrounds for rich and poor alike, with the only distinguishing characteristics sometimes being the luxurious carpets used to make floors in some of the tents.

In rebuilding the city, building owners were encouraged to use earthquake bolts, which operate like giant screws with washers. These are still visible on the sides of many Charleston buildings as round or square metal plates. The bolts, when tightened, pulled buckled walls upright and supposedly added stability in the face of the inevitable: another devastating earthquake. Experts know another quake will strike this fault line; they just can't accurately predict when.

DEAD AND BURIED

In a city with a long history visited by tragedy and catastrophe, the care of the dead has of course seen shifts in fashion. In the 1700s in Charleston, mourning clothing and burial customs could be quite elaborate. Funerals and dress requirements got simpler as time went on, but still involved crepe-wrapped hats and bonnets for both male and female mourners.

In 1861, Queen Victoria lost her beloved Albert the same year the first shots of the Civil War were fired. Given Charleston's still strong ties to England and the fact that the citizens had much of their own to mourn, Charlestonians followed the fashion of Queen Victoria in mourning clothing and even jewelry.

Mourning jewelry woven from the hair of the beloved became quite popular. In a time when thousands of young men were dying and being buried far from home, a lock of hair was about all that could be sent back home to loved ones. The practice of wearing a simple lock of hair close to the heart evolved into wearing elaborate brooches,

necklaces, bracelets and watch fobs woven from hair. Examples of this mourning jewelry can still be found in museums, personal collections and online auctions.

Burials were either beside the church sanctuary or in private family graveyards. Charleston, with its gifted artisan community, boasts elaborate gravestones in all its historical churchyards. (See tour stops #3 and #23.)

On the islands around Charleston, it is not uncommon to find graveyards with traditional African American Sea Island burials, distinguished by the decoration of the grave with broken medicine bottles, pots, utensils, eyeglasses, blue glass and sometimes electrical appliances and other implements used by the loved ones immediately before death. The act of breaking the items may be to symbolize the break between this life and the next, or it may be to discourage theft. Some graves are surrounded by seashells, symbolizing "crossing the water" as their ancestors had first arrived in this country and, at death, as they cross the River Jordan into the Promised Land.

Good Manners

For more than a decade, Charleston has appeared on the top of an etiquette expert's list of best-mannered cities in the United States. Hospitality is a byword in this Southern city, and though the origin is debated, the pineapple—symbol of hospitality—is a common adornment.

Its spirit of hospitality has gotten the city in trouble more than once. During the Revolutionary War, several thousand soldiers and sailors were stationed in the city; after the city surrendered to the Brits, they didn't have much to do except party.

Of course, as a seaport town and former home to scores of pirates, Charleston didn't wait until the war to host its first members of the world's oldest profession, and the tradition continued. In fact, the madam who built a high-class brothel operating around the time of the Civil War is reportedly the model for charitable, gold-hearted Belle Watling in Margaret Mitchell's *Gone with the Wind*. The

Red Barn, present-day home of the Palmetto Carriage Company, was once the site of a popular brothel.

What's a party town without free-flowing spirituous liquors? After Prohibition was repealed by Congress, South Carolina law allowed only beer and wine, not distilled alcohol (though the legislature allowed a loophole for alcohol used for medicinal purposes). By a series of genteel deceptions, the city worked out a deal with the state officials whereby everyone who needed to know was informed whenever state law enforcement officials planned to visit Charleston. On these visits, no alcohol was found, except for a few sellers who could be offered up as sacrificial lambs without endangering the lucrative bar business in Charleston. One of the most famous sources for the moonshine that kept Charleston and her visitors lubricated came down in escorted convoys from Berkeley County's Hellhole Swamp.

SAVING THE PAST

After the Civil War, Charleston's fortunes faltered. No longer was it the elegant and wealthy jewel. It succumbed to a proud poverty, but it refused to bow its head. According to an oft-repeated cliché, the museum-quality houses of the historic sector of the city exist because, after the Civil War, the people were "too poor to paint and too proud to whitewash."

The cliché does not, however, do justice to the long history of preservation that long predated the Civil War. As early as 1835, when discussing how to rebuild St. Philip's Church following a devastating fire, a church member wrote, "Let the old large private dwellings in Charleston be compared with those more recently built, and I am very much mistaken, if the general, as well as the scientific, and the tasteful eye will not give the former preference."

According to writers McLaughlin and Todman, the worst assault on Charleston may have come from the automobile, which brought tourists who then wanted to

Courtesy of Tyler LaCross.

take some of the city home with them, including wrought-iron work and paneling. In 1920, Susan Pringle Frost became an activist for preservation, helping form the Society for the Preservation of Old Dwellings. The battle to preserve the Manigault and Heyward-Washington houses (now museum houses open to the public) and the passage of the first historic district preservation ordinance in the nation (1931) were major victories.

Charleston's unique time machine qualities were not the result of accident but of dedicated, tireless effort. Thanks to those efforts, about 70 pre–Revolutionary War buildings and 850 pre–Civil War buildings can still be found in the city.

As a result, Charleston, with her colorful, peril-fraught past, serves as more than a museum. She celebrates her past—and still won't say no to a good fight or a party.

BIBLIOGRAPHY

"10 years in a row: Charleston named best-mannered city." *USA Today*/Associated Press, November 15, 2005. http://www.usatoday.com/news/nation/2005-01-15-cities-manners_x.htm

60 Famous Houses of Charleston. Charleston *News & Courier* booklet, 1982, 7–9, 12, 19–20, 32, 35, 42, 45, 58.

Across the Cobblestones. Charleston: Junior League of Charleston, 21, 261.

Baldwin, William P. *A Gentleman in Charleston and the Manner of His Death*. Charleston: The History Press, 2006.

Bierstadt, Edward Hale. "Murder—?" In *Curious Trials and Criminal Cases: From Socrates to Scopes*, 251–91. Garden City, NY: Garden City Publishing, 1928.

———. "The Murder That Led to Fame." In *Enter Murderers! Eight Studies in Murder*, 149–73. Garden City, NY: Garden City Publishing, 1934, 1937.

"Charleston's Provost Dungeon." *Sandlapper*, July 1970, 49–52.

Cothran, S., et al. *Charleston Murders*. New York: Duell, Sloan and Pearce, 1947, 4–7, 11–38, 41–68, 71–107, 111–29.

Durham, Frank. "Poe on Sullivan's Island." In *Sullivan's Island Edition of Edgar Allan Poe's The Gold Bug*. Charleston: Tradd Street Press, 1969.

Edgar, Walter. *South Carolina: A History*. Columbia: University of South Carolina Press, 1998, xix, 74–77, 183–84, 340, 384–85, 395, 436–39, 451.

Farrow, David A. *Charleston, South Carolina: A Remembrance of Things Past*. Charleston: Tradd Street Press, 1991, 29–33.

Fraser, Walter J., Jr. *Lowcountry Hurricanes: Three Centuries of Storms at Sea and Ashore*. Athens: University of Georgia Press, 1–3, 240–50.

Gragg, Rod. *Pirates, Planters & Patriots*. Winston-Salem, NC: Peace Hill, 1984, 79–89.

Graydon, Nell S. *South Carolina Ghost Tales*. Columbia: R.L. Bryan, 1969, 3–7, 15–19.

Gribble, Leonard. "Bullets on Sunday." In *Adventures in Murder: Undertaken By Some Notorious Killers in Love*, 24–41. New York: Roy Publishers, 1955.

Hamrick, Tom. "Charleston's Underground Museums." *Sandlapper*, September 1973, 9–12.

———."Murder and St. Philip's Cemetery." *Sandlapper*, April 1972, 20–25.

Hicks, Brian, and Schuyler Kropf. *Raising the Hunley: The Remarkable History and Recovery of the Lost Confederate Submarine*. New York: Ballantine Books, 2002, 53.

Hilborn, Nat, and Sam Hilborn. "A Show of Strength at Sullivan's Island." *South Carolina History Illustrated*. Sandlapper, August 1970, 11–19, 5–60.

Jones, Lewis P. *South Carolina: A Synoptic History for Laymen*. Sandlapper, 1971.

Jones, Mark R. *Wicked Charleston: The Dark Side of the Holy City*. Charleston: The History Press, 2005, 14, 44, 47, 69.

———. *Wicked Charleston, Volume 2: Prostitutes, Politics and Prohibition*. Charleston: The History Press: 2006, 26, 62–63.

Leland, John. *Stede Bonnet: "Gentleman Pirate" of the Carolina Coast*. Charleston: Charleston Reproductions, 1972, 1976.

———. "World Richly Acclaimed 'Porgy.'" *Charlotte Observer*, November 26, 1989, 1B.

Macy, Edward B., and Julian T. Buxton III. *The Ghosts of Charleston*. Beaufort, SC: Beaufort Books, 2001, 16–25, 44–58, 72–79.

"Marriage and Death Notices." *The South Carolina Historical Magazine* 3 no. 34, 1934.

Martin, Margaret Rhett. *Charleston Ghosts*. Columbia: University of South Carolina Press, 1963, 17–34, 40–46, 51–55, 71–82, 92–100.

Mary Long's Yesterday. Video, SCETV.

McLaughlin, J. Michael, and Lee Davis Todman. *It Happened in South Carolina*. Guilford, CT: Globe Pequot, 2002, 128–32, 159–63.

Milling, Chapman J. "Tattoos Marked the Murderers." *South Carolina Illustrated History*. Sandlapper, May 1970.

Moore, John Hammond. *Carnival of Blood: Dueling, Lynching, and Murder in South Carolina, 1880–1920*. Columbia: University of South Carolina Press, 2006, 125, 127–28.

News & Courier, October 1927, November 1933.

Pettus, Louise, and Ron Chepesiuk. *The Palmetto State: Stories from the Making of South Carolina*. Sandlapper, 1991, 17–19, 34, 56–58, 123–28.

Pinckney, Roger. *Blue Roots: African-American Folk Magic of the Gullah People*, 2nd ed. Sandlapper, 2003.

Pressly, Leigh. "Ghostly Tour Hits Charleston Haunts," *Charlotte Observer*, August 3, 1997, 1G.

Rankin, Hugh F. *The Pirates of Colonial North Carolina*. Raleigh: North Carolina Department of Cultural Resources, 1981.

Rhyne, Nancy. *Coastal Ghosts*. Sandlapper, 1985, 55–61, 117, 119–31.

Roberts, Nancy. *Ghosts from the Coast*. Chapel Hill: University of North Carolina Press, 2001, 47–48, 83–94.

Roth, Andrew. *Infamous Manhattan: A Colorful Walking Tour of New York's Most Notorious Crime Sites*. Citadel Press, 1996, 120–22.

Shealy, George Benet. *Walhalla: A German Settlement in Upstate South Carolina*. Blue Ridge, GA: Blue Ridge Mountains Arts Association, 1990.

Smith, Alice R. Huger, and D.E. Huger Smith. *The Dwelling Houses of Charleston, South Carolina*. Lippincott, 1917.

South Carolina Seismic Network, Department of Geologic Sciences, University of South Carolina, http://scsn.seis.sc.edu.

Tilley, John S. *Facts the Historians Leave Out*. Nashville: Bill Coats Limited, 1951, 9.

Wallace, David D. *South Carolina: A Short History 1520–1948*. Chapel Hill: University of North Carolina Press, 1951, 502, 564.

Workers of the Writers' Program, WPA. *South Carolina: A Guide to the Palmetto State*. New York: Oxford University Press, 1941, 98, 100, 188, 197.

Zepke, Terrance. *Ghosts and Legends of the Carolina Coast*. Sarasota, FL: Pineapple Press, 2005, 153–55.

About the Author

Cathy Pickens's first novel, *Southern Fried*, won the 2003 St. Martin's Press/Malice Domestic Award for Best New Traditional Mystery. *Romantic Times BookClub* magazine reviewers named it one of the five Best First Mysteries for 2004. The stories are set in South Carolina, most of them in an Upstate town similar to the one where Cathy grew up; her second book, *Done Gone Wrong*, is set in Charleston.

Cathy's family has lived in South Carolina for almost three hundred years, but she currently lives over the border in Charlotte, North Carolina. She is a frequent speaker on topics ranging from Southern mysteries to managing your creative life to classic true crime stories to the use of poisons.

She holds degrees in financial management from Clemson University and in law from the University of South Carolina School of Law. She is the Wireman Professor of Business at Queens University of Charlotte and is a member of Sisters in Crime, Mystery Writers of America and the South Carolina Bar.